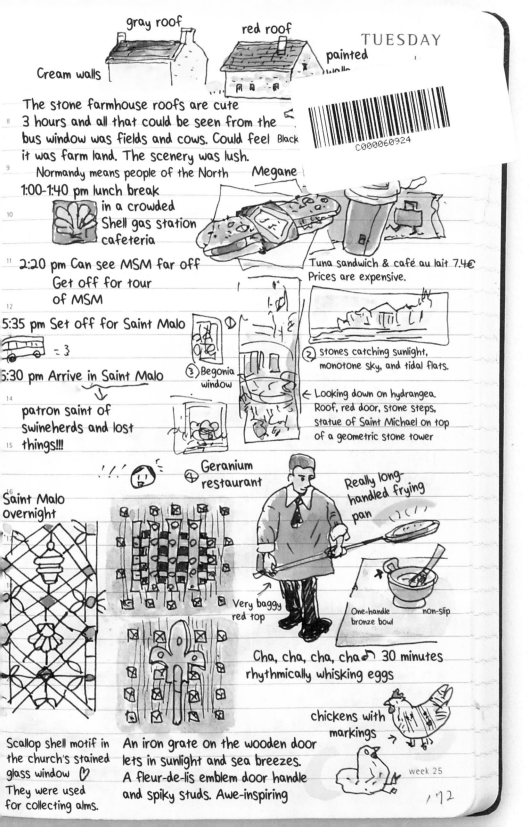

gray roof

red roof

painted walls

Cream walls

The stone farmhouse roofs are cute

3 hours and all that could be seen from the bus window was fields and cows. Could feel it was farm land. The scenery was lush.

Black

Normandy means people of the North

Megane

1:00–1:40 pm lunch break in a crowded Shell gas station cafeteria

Tuna sandwich & café au lait 7.4€
Prices are expensive.

2:20 pm Can see MSM far off
Get off for tour of MSM

5:35 pm Set off for Saint Malo

= 3

② stones catching sunlight, monotone sky, and tidal flats.

③ Begonia window

6:30 pm Arrive in Saint Malo

patron saint of swineherds and lost things!!!

← Looking down on hydrangea. Roof, red door, stone steps, statue of Saint Michael on top of a geometric stone tower

④ Geranium restaurant

Saint Malo overnight

Really long-handled frying pan

Very baggy red top

One-handle bronze bowl non-slip

Cha, cha, cha, cha ♪ 30 minutes rhythmically whisking eggs

chickens with markings

Scallop shell motif in the church's stained glass window ♡
They were used for collecting alms.

An iron grate on the wooden door lets in sunlight and sea breezes. A fleur-de-lis emblem door handle and spiky studs. Awe-inspiring

week 25

172

SKETCH YOUR WORLD

A Guide to Sketch Journaling

Kimiko Sekimoto

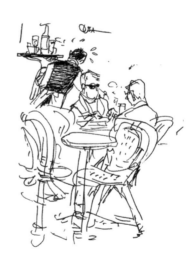

TUTTLE Publishing

Tokyo | Rutland, Vermont | Singapore

Contents

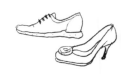

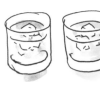 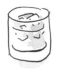

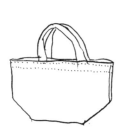

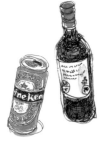

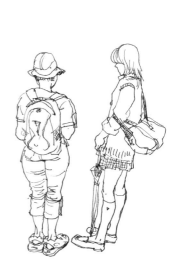

Why I Wrote This Book

Do you like drawing pictures?

This book is for those of you who loved doodling as a child, but for one reason or another you gave it up once you became a busy adult. I carry a notebook and pen with me wherever I go, and in this book I will show you how easy it is to start enjoying the creative expression of sketching once again.

Sketching may sound difficult, but once you start, you'll find it's lots of fun! Your drawings don't have to be incredibly realistic and it's fine if your lines wander or are out of place. I encourage you to start drawing in place of taking notes.

I hope that this book will inspire you to begin sketching and that you enjoy practicing it often, whether it is at a daily meal, in a quaint village while on vacation or wherever you are when the creative urge strikes!

— Kimiko Sekimoto

People and Things in the City

9	M T W T F S S
	1 2 3 4
	5 6 7 8 9 10 11
	12 13 14 15 16 17 18
	19 20 21 22 23 24 25
	26 27 28 29 30

10	M T W T F
	3 4 5 6 7
	10 11 12 13 14
	17 18 19 20 21
	24 25 26 27 28
	31

September

5 MONDAY MONTAG LUNDI
☽ FIRST QUARTER

Izu Lunch 12:30

6 TUESDAY DIENSTAG MARDI

7 WEDNESDAY MITTWOCH MERCREDI

Create line art

Organize line art data

8 THURSDAY DONNERSTAG JEUDI

Line art ⑧ 📖

Send data, organize the rest
Line drawings ⑨

9 FRIDAY FREITAG VENDREDI

· Motifs
· Prep prints
· Mini sketch gallery
· Outdoor prints

12:00-2:30 Yomiuri
Lantern motif
Outdoor coloring

Post office
Outdoor / indoor
Sketch both

✱ ink / paper

10 SATURDAY SONNABEND SAMEDI

11 SUNDAY SONNTAG DIMANCHE

10:30-12:30
Yokohama class
Lamp & lantern motifs

2:00 -
Interview
Bay Quarter

⇒ 6:00
Shibuya

Pick-up at
Sekaido
before 9:00

✱ Colorful Sketch feature in Nov. issue of JJ out Sept. 26

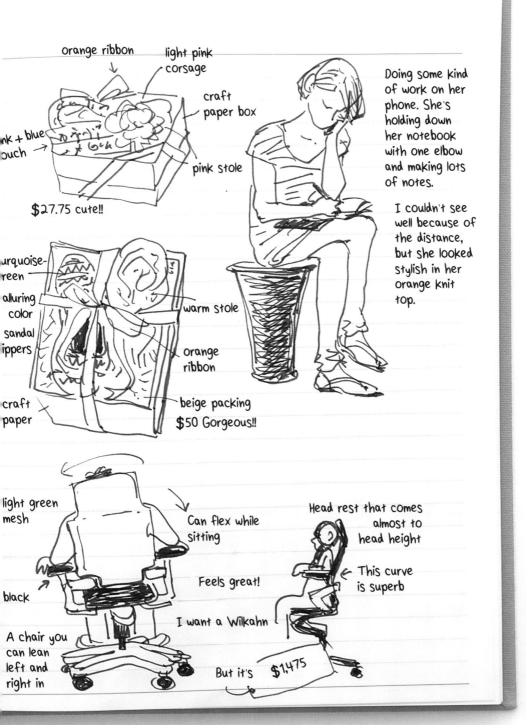

Tools to Have on Hand

Good Pens

It's best to use a water-based, water-resistant felt-tip pen. The ones I use in this book are the Mitsubishi (Uni) water-based ribbed pen Medium MYT-7 and Extra Fine L-50, as well as the Pilot Super Petit Medium and Fine point. Once the ink of water-resistant pens dries, even if it gets wet after, it doesn't run. So if you use paint to add color, the lines will still stand out clearly. I don't use oil-based pens because the ink tends to bleed through the paper.

The thickness of the lines

I'm often asked what thickness of pen tip to use, but I don't have any outright recommendation. It's fine to choose a tip with a thickness and flexibility that you like. If you're not sure, take a look at your own notebook. If you write in tight fine print, then use a fine-tip pen. If your writing is big and bold, try a pen with a thicker tip. The main thing is to find a pen with a thickness you find easy to draw with, and then also have a finer-tipped pen to add in details.

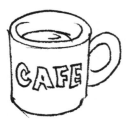

Here, a fine-tip pen has been used (Pilot Super Petit—Fine Point). It makes it easier to include small details like the blocky text.

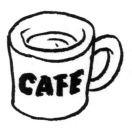

Here, a bold-tip pen has been used (Mitsubishi water-based pen, ribbed—Medium).

Notebooks

There are many different types and sizes of notebook available. To begin with, try drawing in the notebook you normally use. When buying a new one, I recommend the ones that have unruled blank pages. If you will be using color, like for a lunch diary, a watercolor sketchbook is good too.

Paints

When adding color to your sketch notes, you will need transparent watercolor paint, a brush, a palette and tissue. While traveling, if you have transparent watercolors, a watercolor brush pen and pocket tissues, that is fine. You can also use colored pencils. Learn how to add color to your sketches on pages 70-73. Use that information to give it a try.

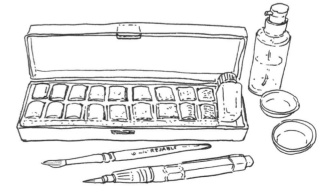

Basic Techniques

Start by practicing lines to get used to drawing with a pen.

It's useful to remember some helpful tips too.

Refer to the following pages while you practice drawing on paper.

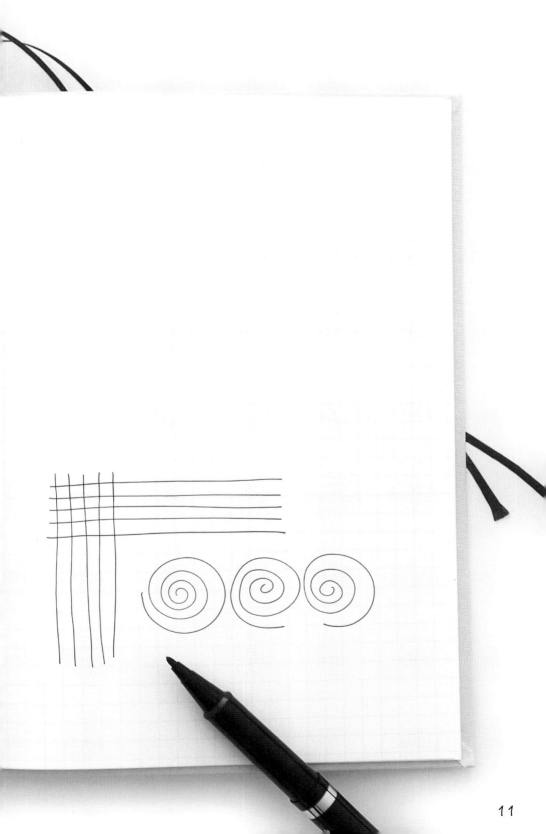

My Summer Vacation Journal

8	M	T	W	T	F	S	S
	1	2	3	4	5	6	7
	8	9	10	11	12	13	14
	15	16	17	18	19	20	21
	22	23	24	25	26	27	28
	29	30	31				

9	M	T	W	T	F	S
				1	2	3
	5	6	7	8	9	10
	12	13	14	15	16	17
	19	20	21	22	23	24
	26	27	28	29	30	

August

22 MONDAY / MONTAG / LUNDI
☾ LAST QUARTER

10:10 –
📖 Meeting with Yagi-san
· Chairs
· Interview
- Café that serves bread

3:30— End 4:00—6:00 Interview

23 TUESDAY / DIENSTAG / MARDI

Create art

At home

24 WEDNESDAY / MITTWOCH / MERCREDI

Create art

At home

25 THURSDAY / DONNERSTAG / JEUDI

Create art

· Organize files & send

7:00 C3 Exit
· Romi Romi ♪ &
· Aloha Café

At home

26 FRIDAY / FREITAG / VENDREDI

8:50 Leave

10:20 - 3:30 finish
Aviation Park outdoor sketch
Yomiuri

27 SATURDAY / SONNABEND / SAMEDI

8:50 Leave

10:30 - 3:30
Epson Shinagawa Aquarium
Asahi Culture outdoor $16

Tobu motif prep

28 SUNDAY / SONNTAG / DIMANCHE

Typhoon No. 12 🌀

~~10:30 - 3:30 Zoshigaya Church Ikebukuro outdoor~~

Called Aug 26

1:00 - 3:00
Tobu class
Usual lesson
(motifs, lanterns,
book, ink, dry flowers)

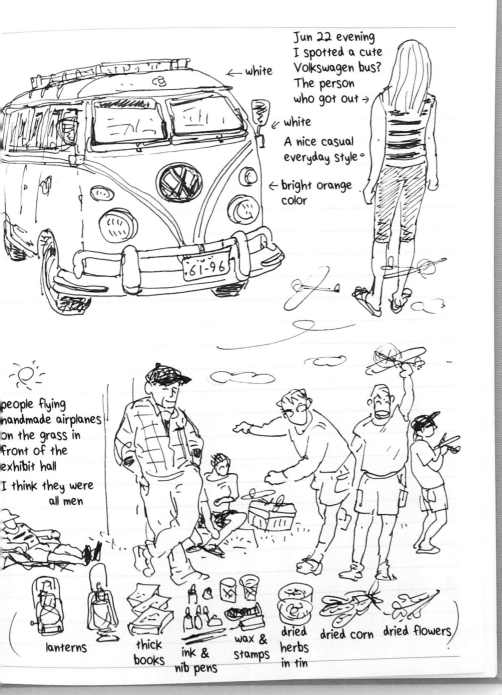

← white

Jun 22 evening
I spotted a cute
Volkswagen bus?
The person
who got out →

← white

A nice casual
everyday style.

← bright orange
color

61-96

people flying
handmade airplanes
on the grass in
front of the
exhibit hall

I think they were
all men

lanterns

thick
books

ink &
nib pens

wax &
stamps

dried
herbs
in tin

dried corn

dried flowers

13

Warm-up Practice

If this is the first time you've drawn pictures or it's been a long time since you have, it's best to start with some warm-up practice. When sketching, the brain tells the hand how to draw what the eyes see and the hand uses the pen to put it down on the paper. This section gives you basic training to get used to and improve moving the pen with your hand and create smooth coordination between your eyes, brain and hand.

Drawing circles, ellipses and ovals

In order to draw circles the size you want them, start by lifting your hand off the paper and drawing a circle. Start with a small circle and then practice drawing larger and larger ones. If you find closing up the outline of the circle difficult, focus on returning to the same start point each time. Once you can draw circles, next try ellipses and ovals. Practice drawing the curves so that the top and bottom ones match. If it looks like the rim of a cup, you've perfected it.

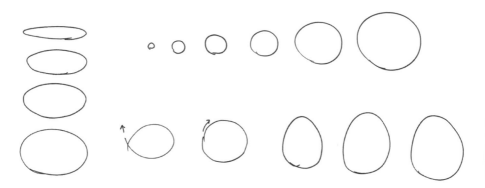

Practice for ellipses (left), circles (top right) and ovals with different curves (bottom right).

Add coffee to the cup

After drawing a coffee cup using an ellipse, try drawing the surface of the coffee in the cup. How is it? There's something a little off with the drawing on the left. The drawing on the right shows that when the curve of the cup and the coffee match, it looks like a natural surface of liquid.

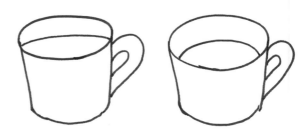

Drawing squares, rectangles and parallelograms

Start by drawing a rectangle, and then draw a second one with the lines slightly tilted to create a parallelogram. Keep drawing rectangles parallelograms, tilting the lines more and more. Next, draw a square, and again keep drawing more, gradually flattening the lines, to form a diamond shape. Try drawing the lines at various angles but with opposite sides that run parallel to each other.

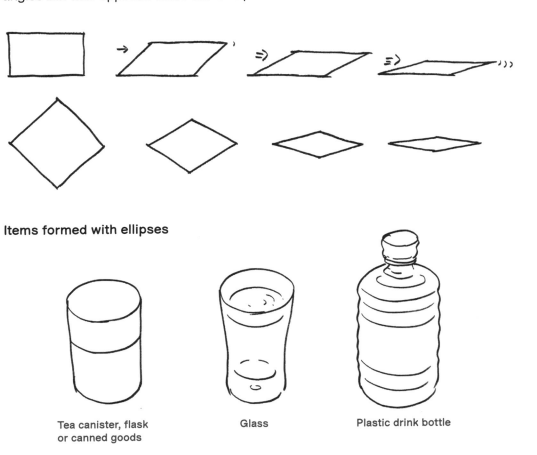

Items formed with ellipses

Tea canister, flask or canned goods

Glass

Plastic drink bottle

Items formed with rectangles and parallelograms

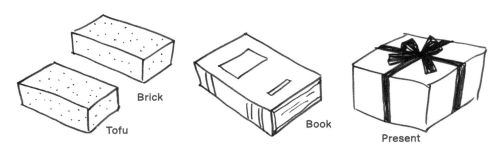

Brick

Tofu

Book

Present

The ABCs of Notebook Sketching

Notebook sketches should include what you want to convey, while leaving out any unnecessary information. If you're going for impression rather than accuracy, sketch loosely to give an overall image, but if you want more accuracy and detail for specific items, just put down that information and leave out the rest.

(1) Observing carefully to decide the angle

Look at an item from all directions and think about which side you want to capture in your sketch. It's easier to draw from an angle that shows three sides as it will convey three-dimensional information, whereas it's more difficult to express realism if you only draw one or two sides. On the other hand, if you want to show the lettering and illustrations on packaging, you should make the surface larger. Sometimes I only draw the front face.

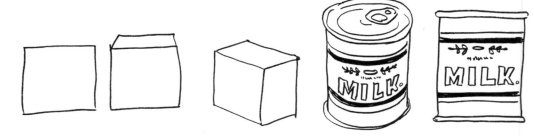

When you want to express volume, draw an object from an angle where you can see both the top and two sides, When you want to sketch a label in detail, draw it from the front.

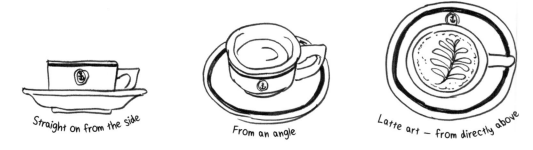

Straight on from the side

From an angle

Latte art — from directly above

Draw a cup from the side to show the pattern (left); from an angle to show the volume of the cup (center); and from the top to capture interesting latte art (right).

(2) Where to start?

Basically, start with the part you want to show. If there are several elements overlapping, start by drawing the top one. When drawing objects that overlap each other or you want to clearly show which is in the front and which is in the back, observe the top and front sides carefully. These will be visible, while the bottom and back sides will be hidden.

Draw the featured shape

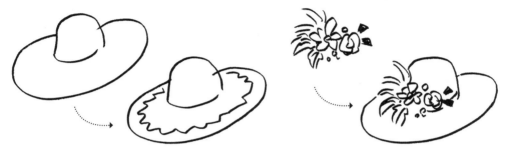

For a simple straw hat, begin with the shape (left), while for an eye-catching decorative hat, start with the decoration.

Draw knowing that some parts will not be shown

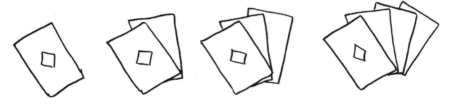

For playing cards, start with the top card.

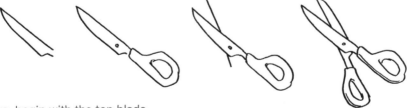

For scissors, begin with the top blade.

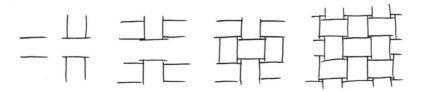

To draw a mesh pattern, look carefully at the way it is layered and draw it in order.

③ Drawing the lines

Although an object's outline may be very beautiful, sketching it with lines can sometimes make it look a bit flat. Work on noting even the slightest change in a line, and pay attention to reproducing the flow of that line. When you come to a corner, make a firm stop with the pen. Check the direction the line will take next and how it will flow, and then continue drawing. Even if the line just gently curves, slow down and record that change.

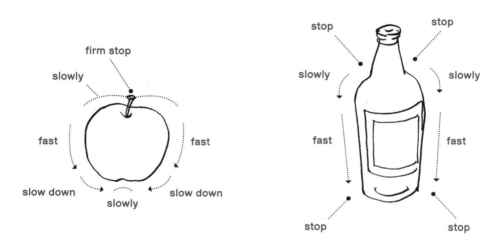

The simpler the object, the more important the outline!

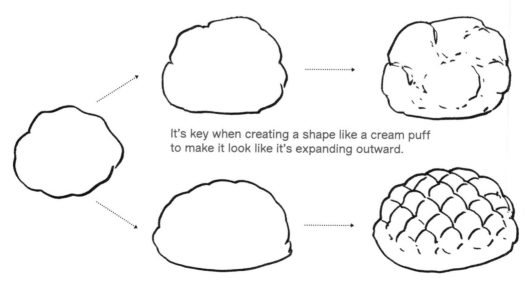

It's key when creating a shape like a cream puff to make it look like it's expanding outward.

For a sweet bun, give it a flat bottom and an uneven top with criss-cross lines.

④ Creating 3D effects and textures

To be able to express a solid shape in a flat sketch, you need to get a little creative. If I was making a formal drawing, I would use light and shadow to express the differences in the surface and the depth, but I don't add shadows to my sketches. It's important to know where and how to sketch a line, so that with that one line, you can express that shape as best you can. Pay close attention to the shape and draw the lines effectively.

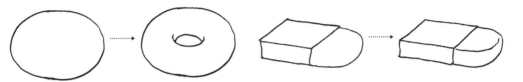

Just by adding one or two lines, you can create a 3D effect.

The same round object can become completely different things!

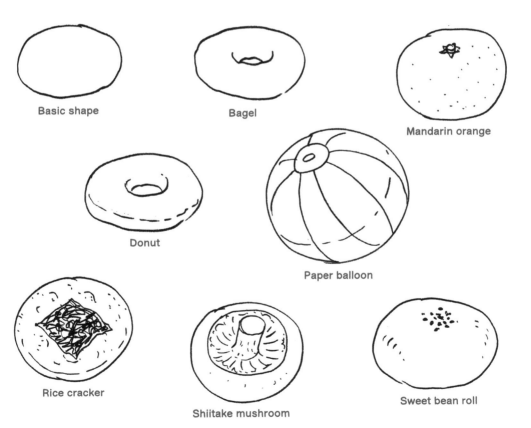

Basic shape

Bagel

Mandarin orange

Donut

Paper balloon

Rice cracker

Shiitake mushroom

Sweet bean roll

19

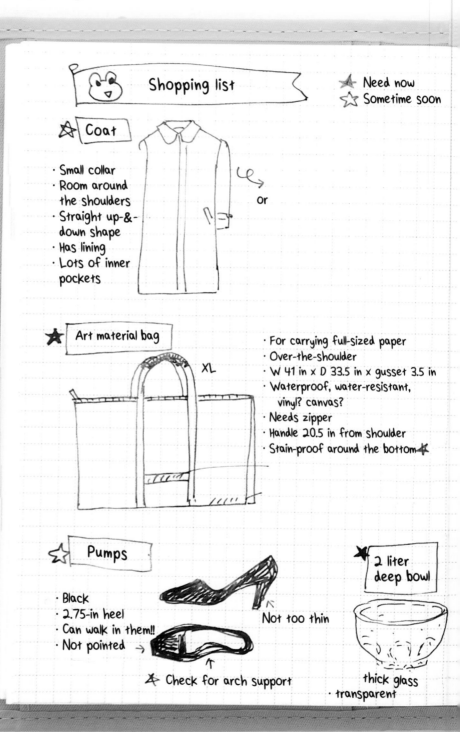

Shopping list

★ Need now
☆ Sometime soon

★ **Coat**

- Small collar
- Room around the shoulders
- Straight up-&-down shape
- Has lining
- Lots of inner pockets

or

★ **Art material bag**

XL

- For carrying full-sized paper
- Over-the-shoulder
- W 41 in x D 33.5 in x gusset 3.5 in
- Waterproof, water-resistant, vinyl? canvas?
- Needs zipper
- Handle 20.5 in from shoulder
- Stain-proof around the bottom ★

☆ **Pumps**

- Black
- 2.75-in heel
- Can walk in them!!
- Not pointed →

Not too thin

★ Check for arch support

★ **2 liter deep bowl**

thick glass
- transparent

Shopping list

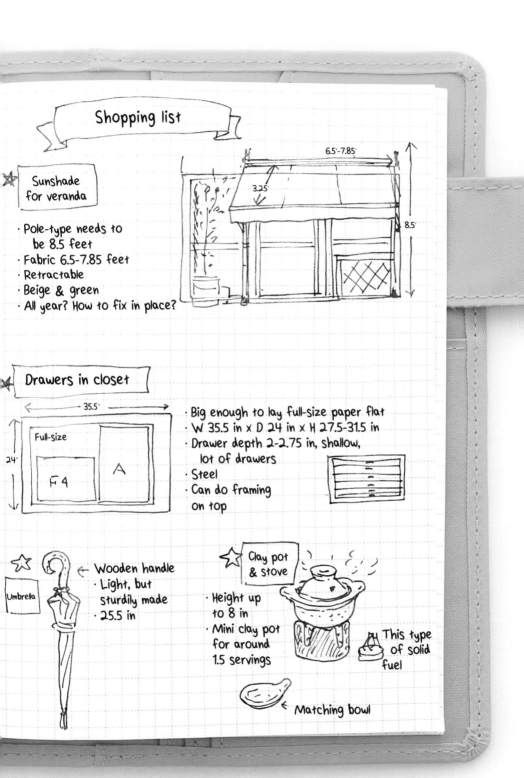

⭐
Sunshade for veranda

- Pole-type needs to be 8.5 feet
- Fabric 6.5-7.85 feet
- Retractable
- Beige & green
- All year? How to fix in place?

6.5'-7.85'

3.25'

8.5'

Drawers in closet

35.5"

Full-size

24"

F 4

A

- Big enough to lay full-size paper flat
- W 35.5 in × D 24 in × H 27.5-31.5 in
- Drawer depth 2-2.75 in, shallow, lot of drawers
- Steel
- Can do framing on top

⭐
Umbrella

← Wooden handle
- Light, but sturdily made
- 25.5 in

⭐ **Clay pot & stove**

- Height up to 8 in
- Mini clay pot for around 1.5 servings

This type of solid fuel

← Matching bowl

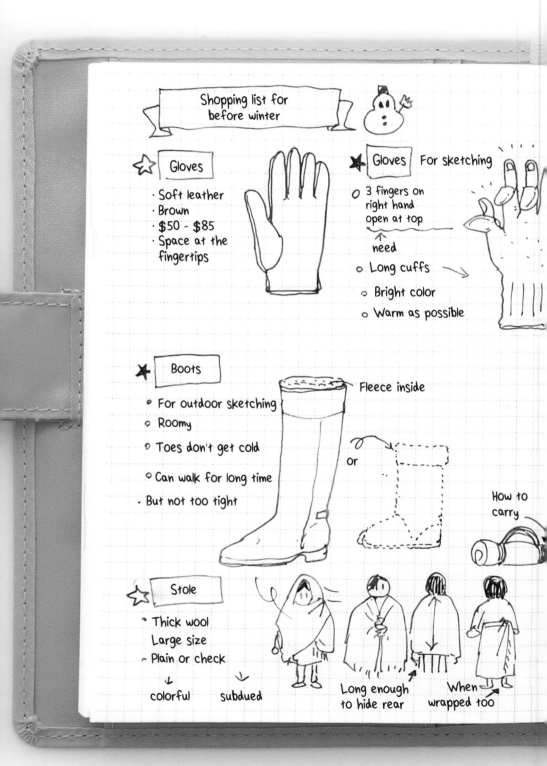

Shopping list for before winter

⭐ Gloves
- Soft leather
- Brown
- $50 - $85
- Space at the fingertips

⭐ Gloves — For sketching
o 3 fingers on
 right hand
 open at top
 ↑
 need
o Long cuffs →
o Bright color
o Warm as possible

✸ Boots
- For outdoor sketching
- Roomy
- Toes don't get cold
- Can walk for long time
- But not too tight

Fleece inside

or

How to carry

⭐ Stole
- Thick wool
 Large size
- Plain or check

 ↓ colorful ↘ subdued

Long enough to hide rear

When wrapped too

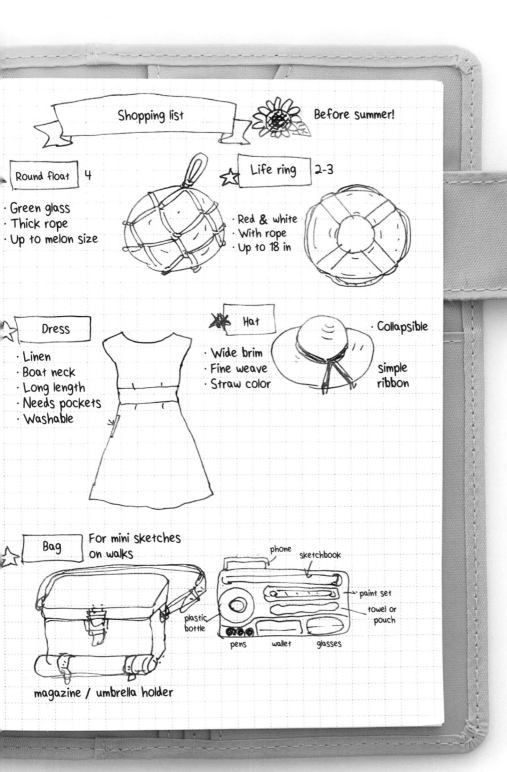

Shopping list
Before summer!

Round float — 4

- Green glass
- Thick rope
- Up to melon size

Life ring — 2-3

- Red & white
- With rope
- Up to 18 in

Dress

- Linen
- Boat neck
- Long length
- Needs pockets
- Washable

Hat

- Wide brim
- Fine weave
- Straw color

· Collapsible

simple ribbon

Bag
For mini sketches on walks

phone
sketchbook
paint set
towel or pouch
plastic bottle
pens wallet glasses

magazine / umbrella holder

23

In a Café

When you have a little free time or want to have a rest while you're out, a cafe is an urban oasis. It feels refreshing to sketch with a drink in one hand. Scribbling when you're an adult is wonderful.

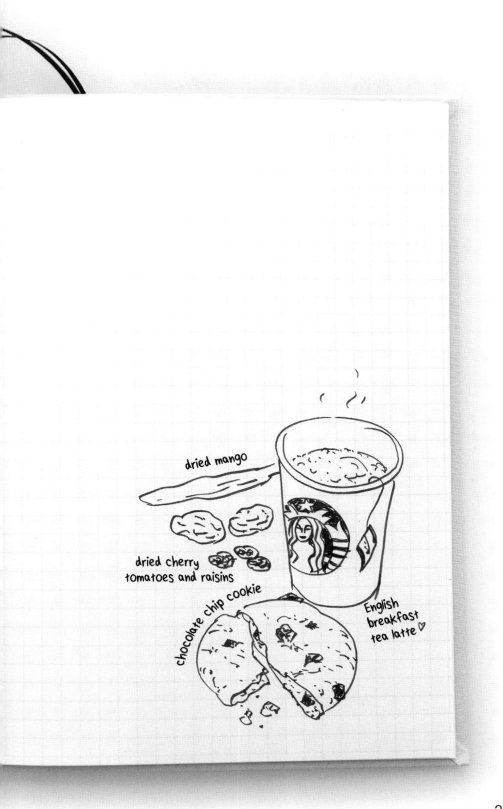

dried mango

dried cherry
tomatoes and raisins

chocolate chip cookie

English
breakfast
tea latte ♡

Cups & Saucers

That time you had a moment of bliss relaxing at your favorite cafe. The occasion you went into a cafe for the first time and it had a nice atmosphere. It's fun to capture those impressions in a simple sketch. Even if it's just a note about a coffee cup, you can vividly recall your impressions from that time.

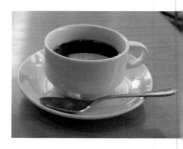

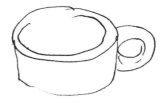

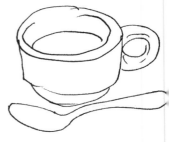

(1) First, start by drawing the rim of the cup. Draw the line showing the thickness of the rim with the same curve, so it forms a solid rim.

(2) Draw the sections of the cup body so that they align with the rim.

(3) The surface of the coffee is drawn like an ellipse inside part of the cup. Draw the outline of the spoon.

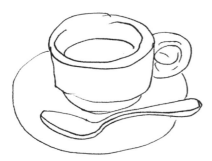

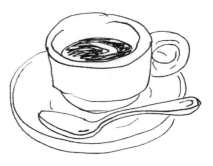

(4) The saucer is also a large ellipse. If you can make it look as if the curve is joining up behind the cup, you've succeeded.

(5) Draw the contour lines of the saucer and spoon. Indicate the dark color of the coffee and you're done.

26

Glasses

It's lovely when you are given a clean, polished glass. Cool and hard to the touch; lines of water and ice that appear refracted and distorted; and the beautiful cut of the glass sparkling in the light. It would be wonderful to capture that moment in a sketch. You might feel it's difficult to do, as the glass and the water are both transparent, but let's try drawing it together.

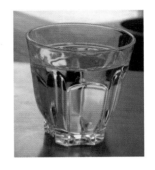

1 Draw the ellipse of the rim and the line showing the thickness, so that the curves match. This glass has a thick rim, so draw it to show this clearly.

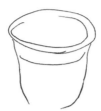

2 Draw the lines for the gentle curve of the sides. Don't worry if the left and right sides don't match.

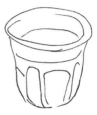

3 Next, draw the cut glass pattern. Then, draw the water surface as a curve within the glass.

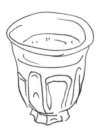

4 Draw the base of the glass, add lines to show the thickness of the pattern, and you're done. If you faintly draw a bit of the pattern on the other side of the glass, it gives a sense of transparency.

A variety of glasses

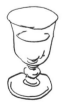

A stem glass. Add a line at the bottom of the base to show the thickness as it gives a sense of stability.

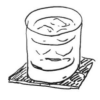

A tumbler. It's good to add ice lines in places without joining them up. Draw them, along with the liquid surface, slightly inside of the glass.

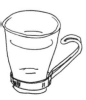

A glass with a metal holder. The thickness of the holder and the vertical lines showing light and dark create a metallic look. Add lines to indicate the holder showing through the other side of the glass.

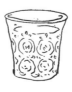

A glass with a decorative surface. You can't see clear lines, but the pattern appears to stand out where the light hits it, so use faint, broken lines.

Cakes

Just looking at adorable cakes can make you feel happy. You hesitate before digging in, not wanting to spoil the perfect shape and wondering where to start nibbling. Before you pick up your fork, make a sketch. Start by practicing drawing a square cake. The trick is to draw from top to bottom, starting with drawing the strawberry on top.

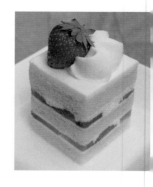

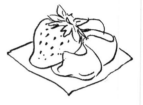

(1) Draw the strawberry cap with jagged lines.

(2) Draw the bluntly pointed shape of the strawberry and make vertical dots for the seeds.

(3) Use gentle curves for the whipped cream and then draw the straight lines of the top of the cake.

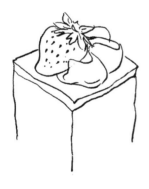
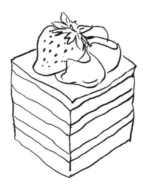
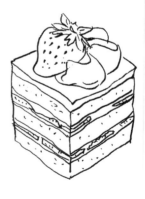

(4) Use two lines to show the thickness of the frosting and then draw three vertical lines running down.

(5) Draw the sponge cake and filling layers from the top down so that they stay parallel.

(6) Add dots to the sponge cake layers and draw cross-sections of strawberries in the filling layers. Okay, time to eat! (If you're drawing a plate too, add that last.)

Different types of cake

Tartlet

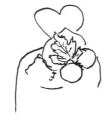
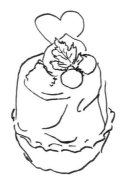
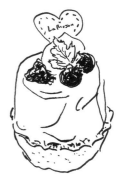

1 Draw the leaf right on the top. Draw it in detail, even though it's small.

2 After drawing the outlines of the blueberries and heart decoration, add the outline of the whipped cream.

3 Gradually draw down to the bottom of the cake. This will determine the size of the base when you draw it.

4 Fill in the blueberries with lines as if adding color to make them look delicious.

Rectangular Slice

1 After drawing parallelogram faces, separate the cream section and cake base with a line.

2 Add markings to show toppings and the texture of the cake and filling to finish.

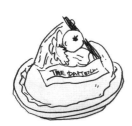

Dome cake slice

Make the letters small so they don't crowd the cake.

Matcha green tea pudding

Fill in the adzuki beans and chocolate with a pen to express the contrasting tones.

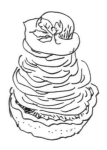

Mont Blanc

Loosely join pairs of lines, working from top to bottom.

Bread

Inhale the lovely aroma of baking bread. The shelves in the shop are full of delicious-looking loaves. A wide variety of characteristic bread, like French and German, is available too. Try drawing your favorite bread. Sandwiches and burgers may look difficult, but if you know the order in which to draw them, they're easy. Then you just add in texture to finish.

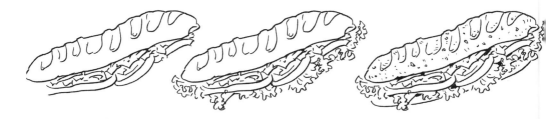

(1) Start by drawing the cut edge of the upper half of the baguette.

(2) Draw the top edge of the upper half, and next add the score lines.

(3) Draw the filling of the sandwich starting from the top. Begin with the chicken.

(4) Next, draw the tomato and lettuce. Move your pen rhythmically to draw the lettuce.

(5) Draw the crusty bread surface and stretch lines in the scoring depressions to create texture. Fill in with black in certain places between the filling elements for a nice three-dimensional effect.

Rolls, buns and pastries

Croissant Draw each layer of the pastry separately to give the impression that these are raised flaky layers.

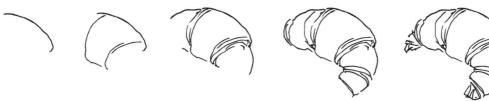

Pain de campagne Draw strong, clear lines on the outer edge of the scoring on this French country bread, and then add faint, broken lines on the inside.

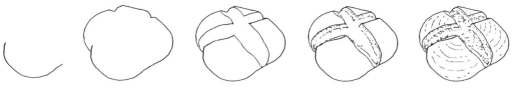

Danish pastry Add light lines to the outside edges of the layers to echo the inside edges and express thickness.

 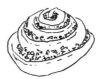 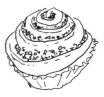

Hamburger Add vertical lines to the buns to give the impressions of plumpness and loft.

 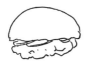

Lunch on a Plate

The one-plate lunch is compact, making it great for sketching. Start with the food at the front and draw the plate last. It's easier if you draw it looking from a 45-degree angle. You can start eating an item as soon as you've drawn it, but if you're not happy with that, sketch everything quickly and eat up before the food gets cold!

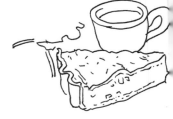

(1) Start with the main item, the quiche. Find the lines easiest to draw and start there.

(2) If you imagine a triangle on top and a rectangle on the side, this makes it easier to create the shape.

(3) Don't worry about drawing the lettuce in detail, just spread out some curved lines. Next, draw the cup with soup in it.

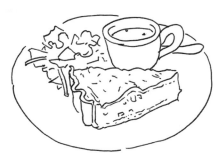

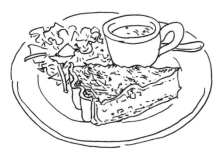

(4) Draw the plate. If you can't draw it all in one pass, it's fine to add lines.

(5) To finish, draw the thickness of the plate, add its indentation, and add lines to indicate the baked surface of the quiche.

Things you'll find in a cafe

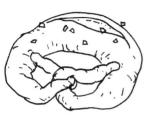

Pretzel

Draw the outline and then add small vertical contour lines to give it a rounded look.

Parfait

Draw the glass to clearly show its thickness and leave space around the filling inside.

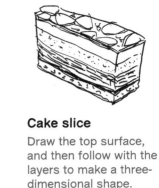

Cake slice

Draw the top surface, and then follow with the layers to make a three-dimensional shape.

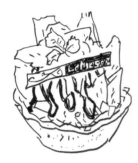

Tartlet

Draw the crunchy parts with straight lines and use curved lines for the creamy textured areas.

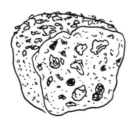

Sub

Move the pen lightly for the lettuce to indicate the leaf tips.

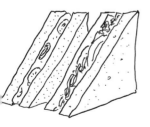

Fig bread

Draw the cross-section and outline of the bread, and then sketch in the fig and walnut pieces.

Sandwich halves

Start by drawing the bread triangle closest to you, then work from right to left.

Fruit tart

Use short rounded lines to represent the juicy citrus segments.

At the Corner Grocery Store

I love grocery stores. If I'm walking in the town or on a vacation, and I spot one, I'll pop right in. I go in thinking I'll just look and suddenly I'll be in the checkout line with some small items in hand. Let's try doing some sketches of cute grocery items.

Wire baskets!!

Paper cups

Small, Medium and Large bowls and paper plates

Kitchen cloths

At Dean & DeLuca in Shinagawa

Tins

You will want to try drawing a cute tin at least once. But when you do it in your own style, it may look kind of strange and flat. That's because the lettering and picture on the tin are flat and don't match the curve of the can. So, while you're drawing, keep in mind that this is a cylindrical shape. If you draw the tin well, the text and graphical elements will be easier to draw too.

Etiquette

When you're about to draw a product in a store, ask the staff if it's fine to do that activity before starting. Be careful not to get ink on the products and avoid standing in a crowded spot.

(1) **Start with the top ellipse.** Be sure not to make the curves on the left and right too sharp.

(2) **Start the outline from the outermost sides of the ellipse.**

(3) **Draw the lip of the lid so that it almost matches the front curve of the ellipse.** Drawing two lines gives it a strong edge.

(4) **Draw the lines down the sides,** add the round base, and the can is completed. Draw the curve of the base so it matches the top. Don't forget to make it a double line.

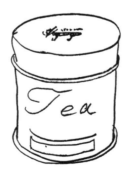

(5) **Now for the text.** This is the fun and important part. Write the characters so that their bottom lines curve the same way as the can does.

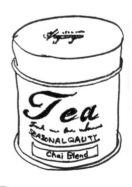

(6) **Neaten the shape of the letters** and it's complete. How is it? Is this can how you imagined it?

Boxes

You want to draw a beautiful box, but you don't know where to start. Take a moment to relax and then start with the outline of the box. Place the box at an angle, so that you can see the best side clearly, as well as the top and one other side. Make the main text large and leave out small details.

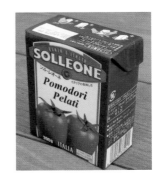

1 There is a lot of small text, so use a fine tipped pen. First, draw the top of the box (for different shapes, it's fine to start from where you find it easiest).

2 Draw lines down from 3 corners and decide the approximate height.

3 Draw the bottom lines almost parallel with the top lines to complete the shape. If the vertical lines are too short to meet the base, add some length.

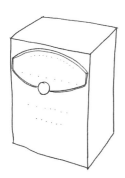

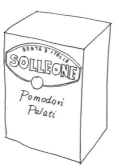

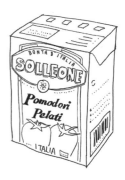

4 Decide which words you will include, and then add guide dots where you want them to go. Make sure to place the dots so they're at the same angle as the box. Small text can be left out.

5 Start writing the outlined text and black lettering, while trying to capture their style.

6 Roughly sketch in the illustrations and other patterns, and it's finished.

Hand Lettering

Skill level 1

SOLLEONE
↓
SOLLEONE
↓
SOLLEONE

The first time you draw, it's easier to draft with a pencil and then draw as if outlining the letters. Erase the pencil lines and the letters will stand out.

Skill level 2

SOLLEONE
↓
SOLLEONE
↓
SOLLEONE

Another way is to use a pencil to draw borders around the letters and then continue drawing while adjusting the width. Be careful of letters with different widths like I and W.

Skill level 3

SOLLE
↓
SOLLEONE

Once you've gotten used to drawing letters, you don't need to use a pencil. You can draw the letters right away with a pen using guide dots to get the height and spacing right. This lets you enjoy the natural flow of handwriting.

Let's try sketching the label

① Leave plenty of space for the letters.

② It's best to go ahead and make the outlined letters bold. Start by drawing the letters at each end and the one in the center.

③ Add the rest of the main letters and the box starts to look good.

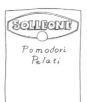

④ Draw the black letters at a slant with slight gaps in-between.

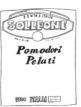

⑤ If you make the lines thicker, it makes them more expressive.

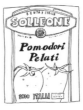

⑥ If you can leave out tiny details and still capture the overall look, you've succeeded.

If the characters don't fit:
If the text information is important, make enough space to fit it all in. If you just want to convey an impression, it's fine to leave out text you either can't read or that is in a language you're not familiar with.

Bottles

You are sure to want to try drawing a stylish bottle too. But it has a more complicated shape than a tin or a box. What should you do? It's fine—don't rush yourself! The biggest difference between a bottle and a box is that the bottle has no clear delineation of faces. Start drawing from the top down, keeping in mind the different widths of the bottle opening, neck and shoulder.

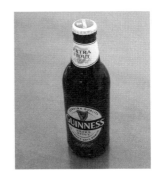

1. Start by drawing the round lid. Add light lines where the neck and shoulder meet to show the different parts of the bottle.

2. Draw the label and logo so that it matches the curve at the bottom of the bottle.

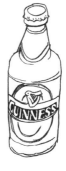

3. The product name and trademark are important. Draw them in detail.

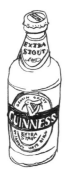

4. Just add the parts of the surrounding lettering that you can. Small text can be left out.

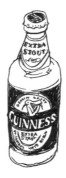

5. Fill in the label and the white seal will stand out, giving a smart overall look.

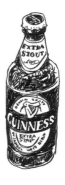

6. Don't color the bottle in completely. Instead, draw lines, leaving little gaps. Leave some parts around the edge of the neck and shoulder free of lines.

39

Containers and Bags

The contents in transparent bottles give different impressions depending on the light and the thickness of the glass. Even a simple salt shaker becomes a sparkling object that you could gaze at forever when held in the light. By sketching parts that are difficult to see, you can sense the thickness of the glass and reflection of light. Try drawing a transparent container!

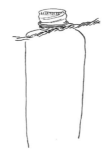

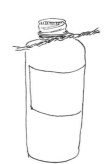

1 Start with the lid. Add lines to give the impression of threads in the lid.

2 Draw the twine by adding a few lines at a time to give it a twined look.

3 Draw the base so it matches the curve of the label.

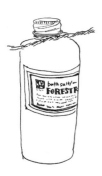

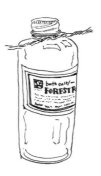

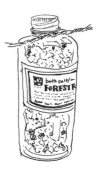

4 Now for the text on the label. Make the product name large and draw abstract markings for the smaller text.

5 Draw lines to define highlights in places that reflect light or where the thickness of the glass makes it difficult to see the contents.

6 Draw the contents, leaving out the parts where the glass is thick or reflects light. If you draw the lines a little faintly and broken up, it makes it seem like you're looking through glass.

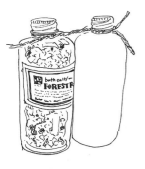 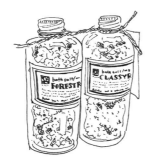 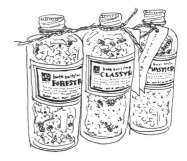

7 Follow the same steps to draw the next bottle.

8 Omit a little of the detail of the contents in the second bottle.

9 Omit even more detail of the contents in the third bottle. If there are many instances of the same items inside, draw a few very well and then draw the rest just to suggest their features.

A variety of clear bottles and bags

The bottle on the left with clear liquid has been drawn with no detail inside, while the one on the right has little marks to show the contents.

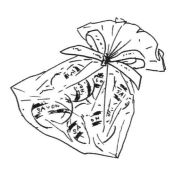

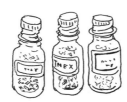

Don't draw the contents all the way to the sides to indicate thick glass.

Draw faint, broken lines for the contents. Leave parts where light reflects in such a way that you can't see inside the bag.

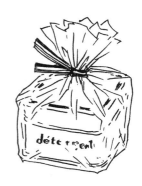

Draw the water line in the vase. The stem looks distorted because of the curved surface of the glass and refraction of the water, so draw it without joining up the lines.

Baskets

Hand-woven baskets have attractive organic curves. Some are made finely with an intricate weave, while others use thicker material and are put together roughly, so they express a variety of textures from relatively smooth to coarse. When you want to draw to give the impression of a shape, don't worry about including a lot of detail—just use light lines to indicate the weave.

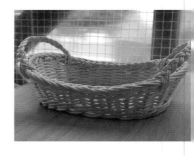

1. Draw the characteristic shape of the basket and the gentle curve of the handles.

2. Draw the outline of the lip.

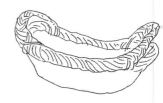

3. Draw the lip and handles so they appear separate. For the handles, draw 3 sets of parallel lines and alternate them to create a braided look.

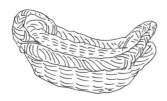

4. Draw the lines on the side of the basket in a series of rows, and it's complete.

Ways of weaving

If you want to keep a study of woven patterns, you can do this by making an enlarged sketch of each one. Practice drawing a lot of different patterns, while imagining how the parts you can't see are connected.

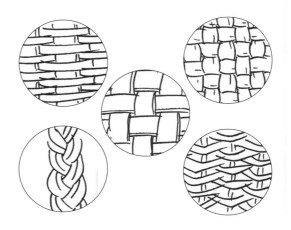

Cloth Bags

Cute fabric bags can be used as lunch bags, shopping bags and more. Depending on the thickness of the fabric, creases will appear differently on these items. Thick cloth will have straight lines and thin fabric will have softer curves. The length of the handles depends on what the bag is used for, so make note of the characteristics and practice drawing various different ones, like a shoulder bag or a handbag.

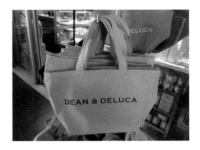

1 Start by drawing the handle.

2 Draw the width of the handle.

3 Next, draw the bag opening. The key point is to get a good balance between the width of the bag and length of the handles. Look carefully at where the handles begin.

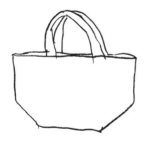

4 Draw the outline of the bag and add the back handle.

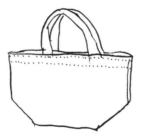

5 Draw dotted lines for stitches, giving the impression of thick fabric.

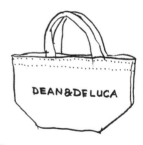

6 Draw in the logo, and you're done.

Light Fabric Tote Bags

The way fabric folds and creases depends on how thick it is. In other words, if you look carefully at those and draw them accurately, you can express the texture and weight of the fabric.

Gifts from My Friends

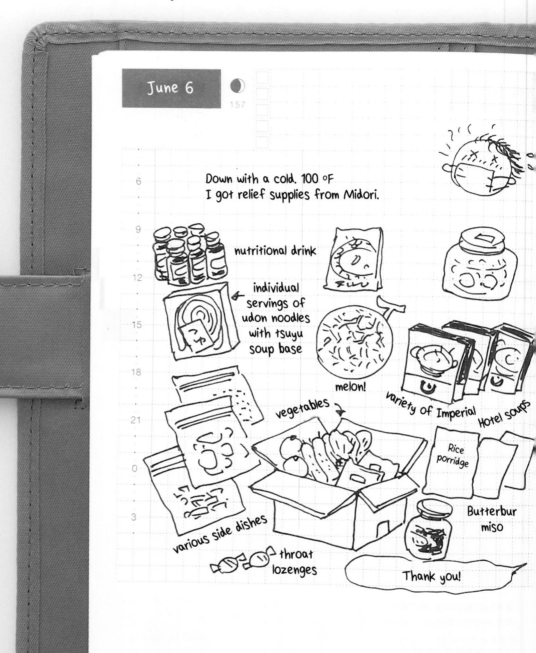

Down with a cold. 100 ºF
I got relief supplies from Midori.

nutritional drink

individual servings of udon noodles with tsuyu soup base

melon!

variety of Imperial Hotel soups

vegetables

Rice porridge

various side dishes

throat lozenges

Butterbur miso

Thank you!

44

98.6 °F

I got a book from Ban-san.
It has a collection of interviews with Tasha Tudor.
Thank you!

6

They
remembered me
saying I wanted
to visit Tasha's
Corgi Cottage.
I'm really happy.
It's so thoughtful.

	1	2	3	4	5	
6	7	8	9	10	11	12
13	14	15	16	17	18	19
20	21	22	23	24	25	26
27	28	29	30			

6

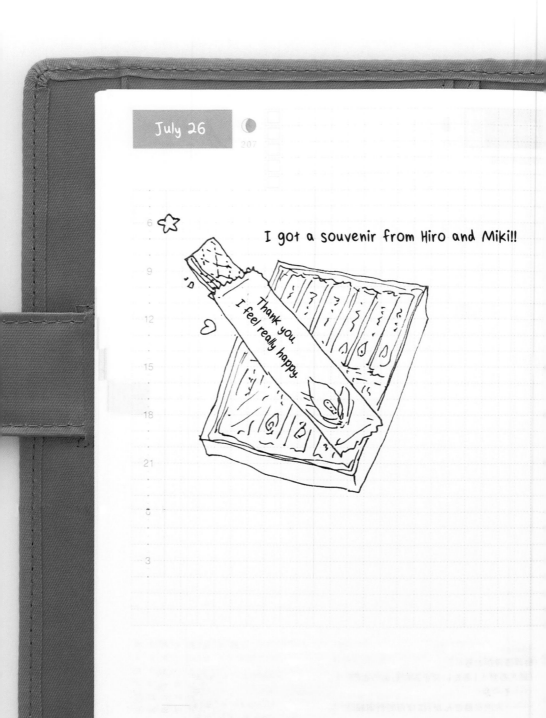

I got a souvenir from Hiro and Miki!!

Thank you.
I feel really happy.

9

12

15

18

21

0

3

What a surprise!!

Guess what!! I got a TV from Yuka as a present.

A box from Amazon I don't remember ordering

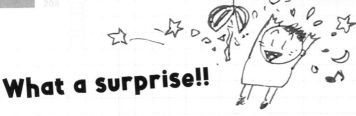

REGZA

22 inch

TOSHIBA

Huge bag

With a TV inside!!

7

Two days ago, she asked about digital TVs and I told her I still had analog. Today a box arrived from Amazon that I didn't remember ordering. I opened it with no idea what it was and inside a huge bag was an LCD-display digital TV. What!? She must have ordered it from NY. I'm so thankful.

6

9

12

15

18

21

0

3

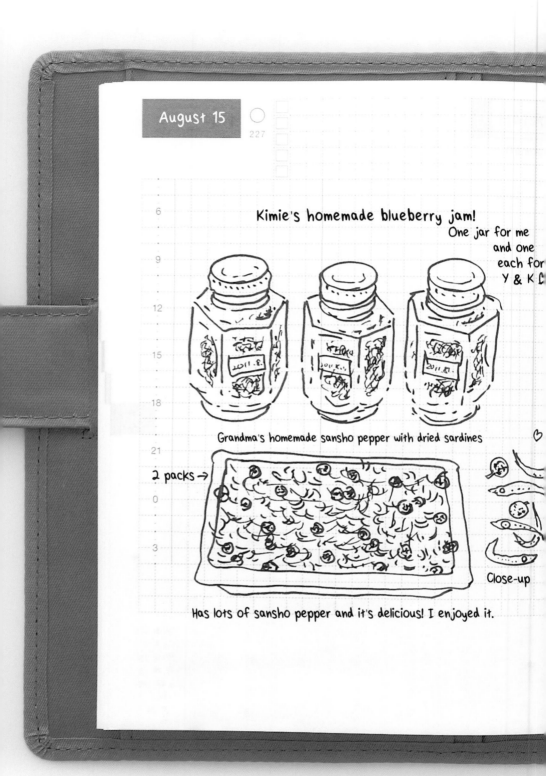

Kimie's homemade blueberry jam!
One jar for me
and one
each for
Y & K

Grandma's homemade sansho pepper with dried sardines

2 packs →

Close-up

Has lots of sansho pepper and it's delicious! I enjoyed it.

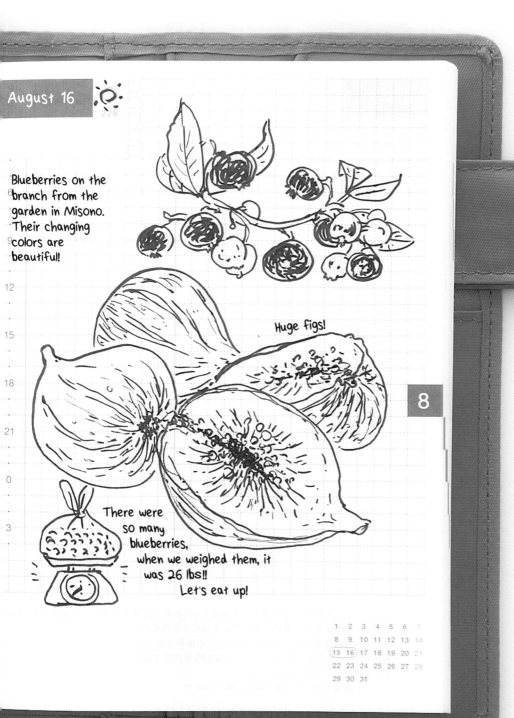

Blueberries on the branch from the garden in Misono. Their changing colors are beautiful!

Huge figs!

8

There were so many blueberries, when we weighed them, it was 26 lbs!! Let's eat up!

1 2 3 4 5 6 7
8 9 10 11 12 13 14
15 16 17 18 19 20 21
22 23 24 25 26 27 28
29 30 31

49

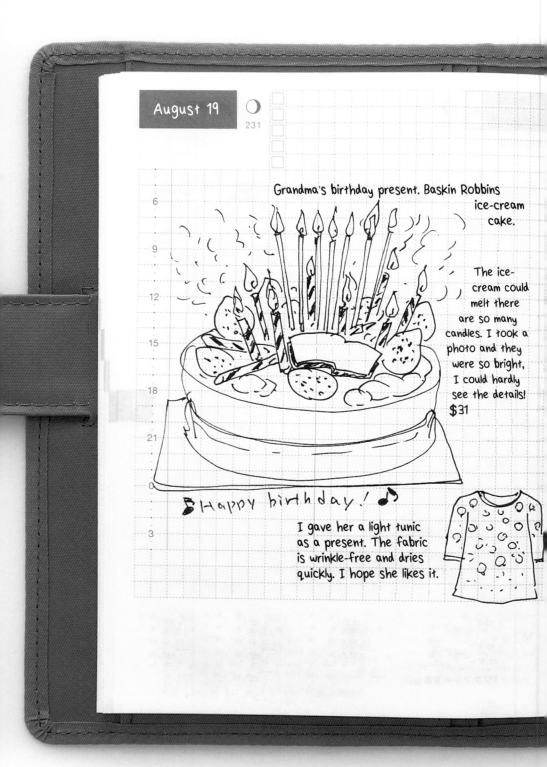

Grandma's birthday present. Baskin Robbins ice-cream cake.

The ice-cream could melt there are so many candles. I took a photo and they were so bright, I could hardly see the details! $31

♪ Happy birthday! ♪

I gave her a light tunic as a present. The fabric is wrinkle-free and dries quickly. I hope she likes it.

232

6

9

12

15

18

21

0

3

For Midori

I gave her some postcards that she'd asked about before.

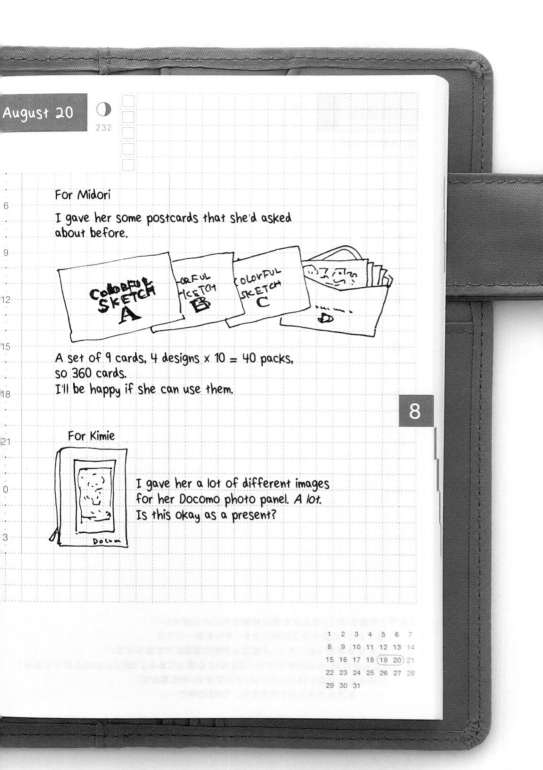

A set of 9 cards, 4 designs × 10 = 40 packs,
so 360 cards.
I'll be happy if she can use them.

8

For Kimie

I gave her a lot of different images
for her Docomo photo panel. *A lot.*
Is this okay as a present?

Docomo

1	2	3	4	5	6	7
8	9	10	11	12	13	14
15	16	17	18	(19	20)	21
22	23	24	25	26	27	28
29	30	31				

In the Kitchen

I take a moment to observe the kitchen by the stove while boiling corn-on-the-cob. The kitchen utensils and tomatoes all seem to be shining.

Try sketching this ordinary moment from everyday life.

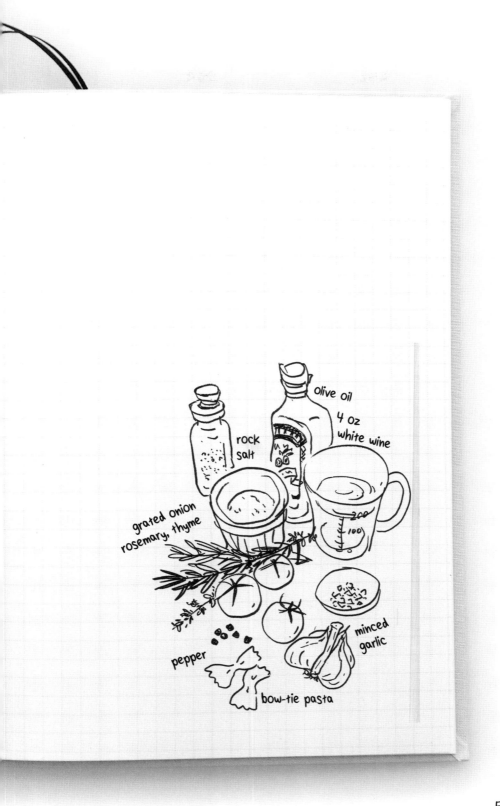

rock salt

olive oil

4 oz white wine

grated onion rosemary, thyme

minced garlic

pepper

bow-tie pasta

Fruits and Vegetables

When you arrange vegetables to begin cooking, it brightens up the kitchen with round, elongated and bumpy shapes. Take a closer look at these familiar vegetables and you'll see how wonderful the are. Draw a bell pepper starting from its impressive stem and a radish from its characteristic wavy root.

Bell pepper

1 Draw the thick, curving stem with bold, strong lines.

2 Add lines to show the bumps and creases, and then the stem is complete.

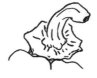

3 Next, draw the swell of the "shoulders."

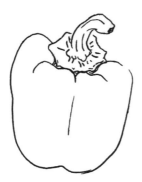

4 Slow the pen each time you reach a curve in the outline.

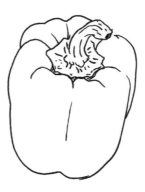

5 Finish drawing the curve all around, and you will have a shiny, fresh bell pepper.

A selection of fruit and vegetables

Radish Draw the round part and the root separately. Gently move your wrist while drawing the leaves.

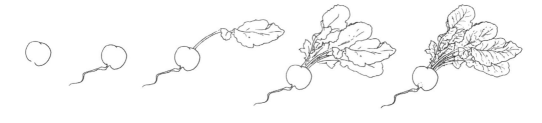

Grapes Start drawing from the place where you can see a whole grape. If you add a dot to the outside of each one, they immediately appear more grape-like.

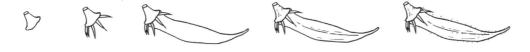

Okra Add lines to create a fuzzy texture. The trick is to take your time and draw the bristles facing outward.

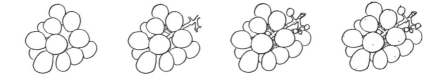

Snow peas Instead of drawing circles, draw gentle, short curves to indicate the swell of the peas inside the pod.

Tomato Start by drawing the body, and then move on to add the thin stem and calyx.

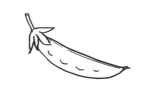

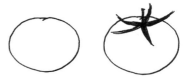

Kitchen Utensils

I have a lot of cooking utensils in my drawers. I'm always excited to find new kitchen items to purchase. Try doing some quick sketches of ones you've used for years and those that you want to buy soon.

Toaster

 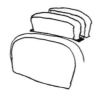 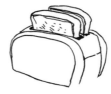 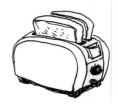

1 Start drawing from the side panel that you can see in its entirety.

2 Draw the first line of the bread slot, and then sketch the lines of bread coming out from there.

3 Draw the back edge of the toaster and you'll begin to see the complete shape.

4 Fill in the switch, timer, and base with black pen. Add lines and more details for a finished appearance.

Whisk

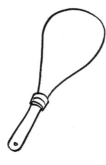 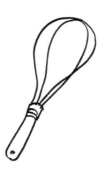 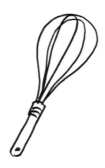 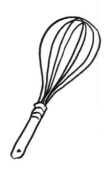

1 This has such a simple shape, but it's difficult when you try to draw it. Start by sketching 1 wire.

2 The 2nd wire is key. Draw it in one complete line without stopping, keeping a loop-shape in mind.

3 Draw a 3rd wire, changing the angle slightly.

4 With the 4th wire, it's now looking like a whisk, so it's fine to leave out the rest.

56

Pepper mill

 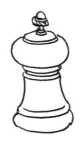 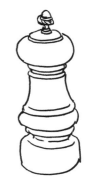

(1) At a glance, this looks difficult, but let's start from the metal fixture on the top.

(2) Once you've drawn the metal disc, add the bulbous section, comparing it to the part above.

(3) Continue drawing the next sections down.

(4) The base is important. Carefully draw its rounded shape. Even if the curves above are a little off, if the base looks solid, the whole mill looks unified.

Kettle

 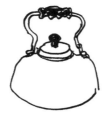 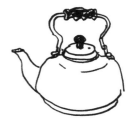

(1) The handle was very cute, so I started with that.

(2) Draw a black knob and then the ellipse of the lid around its base.

(3) Match up the length of the handle with the lid. Draw a big curve for the base.

(4) Don't forget the spout opening and the little hole in the lid. Now you can draw various kinds of teapots.

Other kitchen utensils

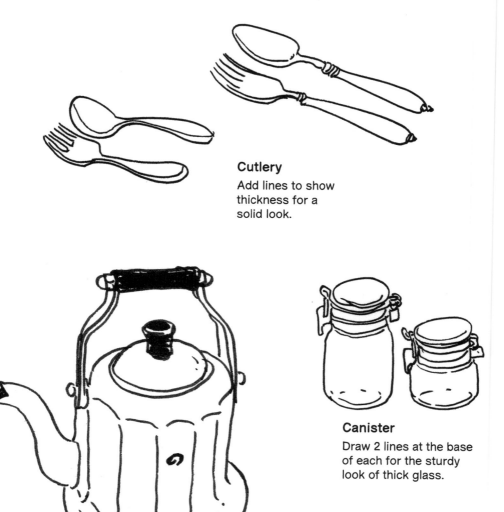

Cutlery
Add lines to show thickness for a solid look.

Canister
Draw 2 lines at the base of each for the sturdy look of thick glass.

Enamel kettle
Indicate smooth transitions with broken lines.

Spatula
Draw the line to indicate the thickness of the edge, thinning it toward the tip.

Oven mitt

If you draw the quilting seams with wavy lines, it creates a padded effect.

Brush

Use bold, straight lines for the bristles.

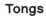

Tongs

Be sure to clearly draw the screw at the joint.

Pot

If you draw the ellipses of the lid ridges with wider spacing in front and narrower spacing at the back, it will look as if it's domed.

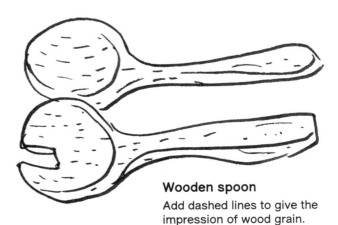

Wooden spoon

Add dashed lines to give the impression of wood grain.

Recipe Notes

Illustrated notes are a great way to remember tips that you figured out when you made meals, as well as points that aren't included in recipes. If you add information on how to cut things and what temperature to use alongside the pictures, it makes the recipe easier to understand.

When you want a little snack

Super easy baked apple

Frying pan version

① · Thickly slice 1 apple and cut out the core.

② · Melt 4½ tbsp butter in a frying pan, then add 3¼ tbsp sugar and the apple.

③ Cook until both sides are a caramel color, sprinkle on lots of cinnamon, and it's ready!

Great topped with vanilla ice cream!

As you can see, the sliced apple is shown roughly with horizontal lines.

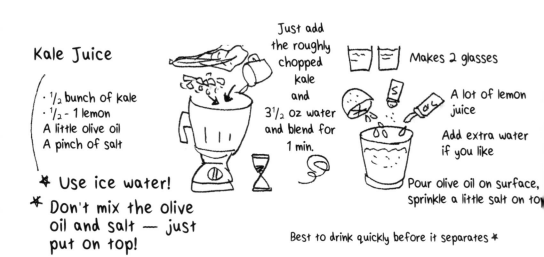

Kale Juice

· ½ bunch of kale
· ½ - 1 lemon
A little olive oil
A pinch of salt

� Use ice water!

✳ Don't mix the olive oil and salt — just put on top!

Just add the roughly chopped kale and 3½ oz water and blend for 1 min.

Makes 2 glasses

A lot of lemon juice

Add extra water if you like

Pour olive oil on surface, sprinkle a little salt on top

Best to drink quickly before it separates ✳

Even simple information can be imagined more easily with an illustration.

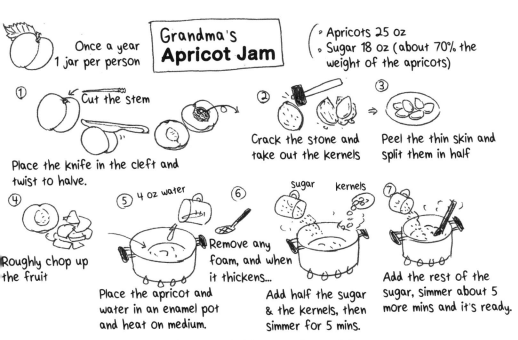

Grandma's Apricot Jam

Once a year — 1 jar per person

- Apricots 25 oz
- Sugar 18 oz (about 70% the weight of the apricots)

① Cut the stem
Place the knife in the cleft and twist to halve.

② Crack the stone and take out the kernels

③ Peel the thin skin and split them in half

④ Roughly chop up the fruit

⑤ 4 oz water
Place the apricot and water in an enamel pot and heat on medium.

⑥ Remove any foam, and when it thickens...
sugar kernels
Add half the sugar & the kernels, then simmer for 5 mins.

⑦ Add the rest of the sugar, simmer about 5 more mins and it's ready.

✳ Even if it's a little runny, it's fine as it will thicken up when cooled.

Another benefit of this type of memo is that you can see the utensils needed at a glance. Even if you don't include everything, just adding little cues makes the recipe easier to understand.

Grandma's Delicious Yuzu Marmalade

- 4-5 Yuzu citrus fruits (21 oz)
- 14 oz sugar (about 3:2 ratio)
- 1/2 tsp citric acid

① Preparation
Carefully wash the uneven surface, cut in half, and juice them.
peel — Remove the inside flesh. Thinly slice and steep in water.
Leave for 2-3 hours, changing the water now and then ⇒ Squeeze out the water Ⓐ
pips — Set aside.
juice — Ⓒ
Add to 13 1/2 oz water and rub well, then set aside. ✳ keep the water
After 2-3 hours, remove the pips.
Thickened pip Ⓑ water

② Put the yuzu peel into an enamel Ⓐ pot
Ⓑ Pour in all the pip water ⇒
Add citric acid and heat on medium for 15 mins

③ When the peel is soft, add half the sugar and heat for 5 mins
Add the rest of the sugar, cook another 5 mins on low heat

④ Lastly, add the juice Ⓒ and bring to a boil
Ready!!

Tip: Create a shorthand representations of the flames for high, medium and low heat.

Street Scenes

You come across a beautiful scene in town. You take a photo, but later when you check it, for some reason it doesn't look compelling. That's because the moment has been lost because you're seeing the whole scene from a new perspective. Instead of trying to capture the entire view, I sketch small scenes that catch my attention.

Signs

Shop windows, doors, buildings, etc.—it can be overwhelming to decide where to start sketching. When you feel that way, try drawing just one shop sign. One that truly reflects the shop's character makes for a great looking sketch.

(1) Start by drawing the circles of the life-ring motif. It's going to have text, so make sure it's large enough.

(2) Add the shape of the ribbon. It's not a perfect representation, but let's keep going.

(3) Draw the text on the larger side, so the white letters stand out clearly.

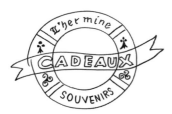

(4) Add the partition lines and draw the text. Leave a little space between the decorative letters.

(5) Fill in the vertical lines of the decorative lettering bolder. This part takes some careful work. Fill in the dark parts of the ribbon and life ring with pen to give the drawing a much more finished look.

(6) The hanging bracket was interesting, so I drew that too. I filled out the curve at the bottom of the ribbon. If something isn't working at first, don't panic and just keep improving it.

A selection of signs

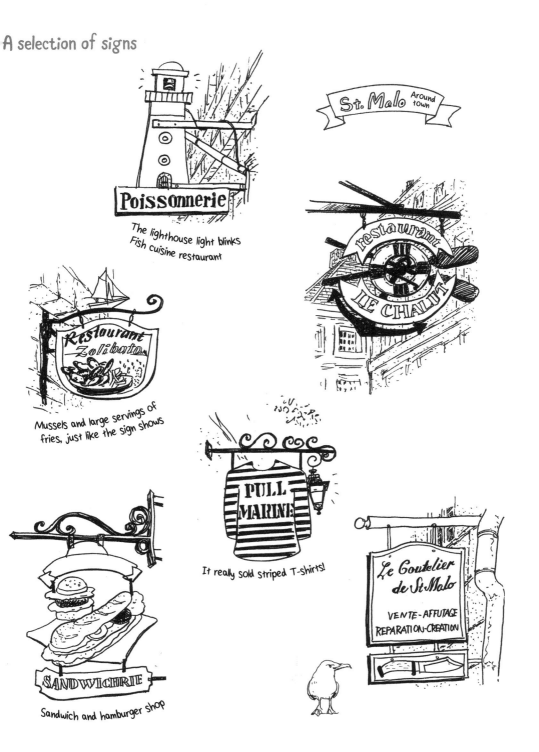

Poissonnerie
The lighthouse light blinks
Fish cuisine restaurant

St. Malo Around town

restaurant
LE CHALUT

Restaurant Zolibato
Mussels and large servings of fries, just like the sign shows

PULL MARINE
It really sold striped T-shirts!

SANDWICHERIE
Sandwich and hamburger shop

Le Coutelier de St Malo
VENTE-AFFUTAGE
REPARATION-CREATION

Draw the parts you like in detail. Leave out the rest. It's fine just to create a rough impression without including tons of detail. If you sketch in a bit of the surroundings, it will bring the whole scene back to life in your mind.

Chairs

When I come to a place where there's a chair, I feel relieved to this simple symbol of civilized life. And when I get offered a seat in a country I'm visiting for the first time, I relax and the conversation flows. Chairs have a mysterious power. Make sketches of chairs that make an impression on you at the street corner cafe, at the bus stop and in the park.

1 The curve of the back was interesting, so here I drew a graceful outline.

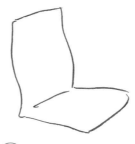

2 Draw the seat and then a line where it joins the back.

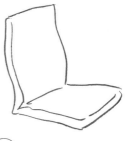

3 Draw a second line within the outline to show the thickness of the cushion.

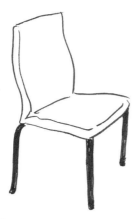

4 Draw the 3 legs nearest to you. Draw the closest leg to extend farther down the page and make the back right leg curve outward slightly.

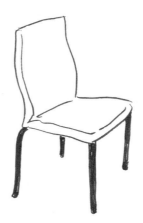

5 Look carefully at where I've positioned the 4th leg. It comes out from the back corner of the seat, accounting for the implied slight curve at the top of the leg, which is hidden by the seat.

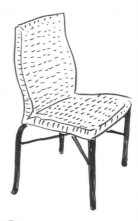

6 The surface of the chair has been constructed of woven cord, but just draw a series of short lines to give that impression to complete the sketch.

Various kinds of chairs

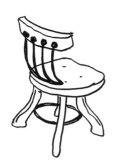

For this sturdy wooden chair, draw each line boldly.

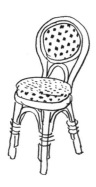

This rattan chair has a light, stylish feel. Omit some details, so it doesn't become too uniform.

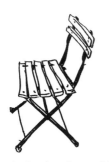

The whole structure of this chair is flimsy, so draw it quickly. On the chair back, show the warped iron and the screws holding the wood to add character.

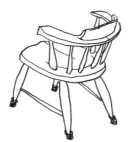

Draw the spindles lightly, flaring them out in the middle. The back legs jut out quite a bit from the back of the seat.

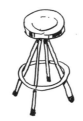

A cool chrome stool. Draw black reflection lines on the side of the seat to add character.

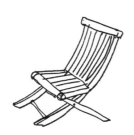

With a folding chair, the screw holding the legs together is an important detail.

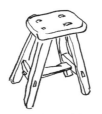

The wood on this stool has been worn down to rounded edges. Move the pen gracefully.

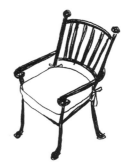

Make bold, decisive lines to create the impression of the rigid iron sections of this patio chair. Slow down to lightly draw the cloth cushion.

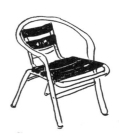

For this steel chair, draw the long curve from the backrest to the armrest to the front legs using relaxed lines.

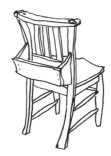

The Bible pocket on the back of this vintage chapel chair is lovely. Draw a line to show its thickness. If the lines aren't long enough, it's fine to add on to them.

Windows

Windowsills are very attractive as they give you a sense of the person living within. Here, we have nice window frames, beautifully arranged curtains and lovely flowers. Let's focus on these points as we draw. If you show a little bit of the wall surrounding the frame as well, it gives the impression of the architecture of the building.

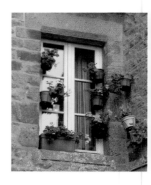

Etiquette

You'll want to get closer to look at the windowsill, but remember to respect people's privacy.

(1) Start by drawing the edge closest to you to determine the angle.

(2) The bases of the flowerpots are visible, so make marks to show approximately where they are.

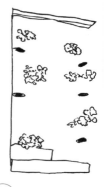

(3) Draw the flowers in bunches, not individually.

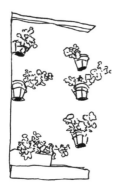

(4) Draw arched rims on the flowerpots to emphasize the impression that they're above eye level.

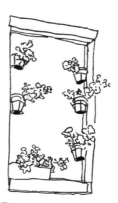

(5) Draw the thickness of the wall on the right.

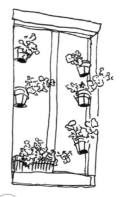

(6) Start drawing the *mullion* (vertical divider) from the center.

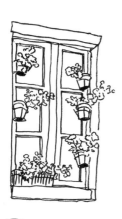

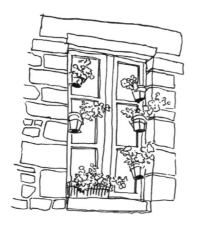

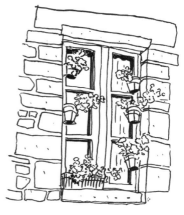

(7) Draw 3 squares vertically to define the panes and add double lines to show the thickness of the window frame.

(8) Draw the adjacent stonework too.

(9) Dots are used to represent the texture of the stone and broken vertical lines are used to indicate the curtains. Add shadows to 2 sides of the windows for a finishing effect.

An assortment of windows

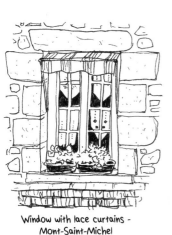

Window with lace curtains - Mont-Saint-Michel

A window with lace curtains. The interior is filled in with black to add attractive contrast.

A small window for light MSM

An opening for a small window in an old stone building.

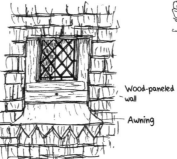

Wood-paneled wall

Awning

For wooden frames, add short, light lines to give the impression of wood grain.

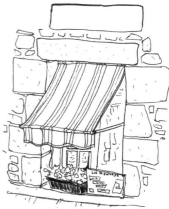

Petunia window - Mont-Saint-Michel

The awning made a nice, stylish impression. It's easier if you draw it from an angle.

69

Adding Color to Your Sketches

If you can add simple colors to your sketches, it's much more fun. Rather than painting everything to look real, add color sparingly as if making a note of the impression of that color. Use diluted colors to allow the sketch lines to stand out. You can use brighter colors than what you really see and don't add shadows. Each type of paper has different properties. Try using watercolors and colored pencils, and discover what works for you. If you use a watercolor paper sketchbook, you can paint even more beautifully.

What to prepare

If you're painting while traveling, all you need to pack is transparent watercolor paints in pan format,* a brush and tissues. To make it easier when you working at home, use the pan-format transparent watercolors, 2 watercolor brushes, a palette, a cup for water, and a paper towel. You can use colored pencils too, if you like.

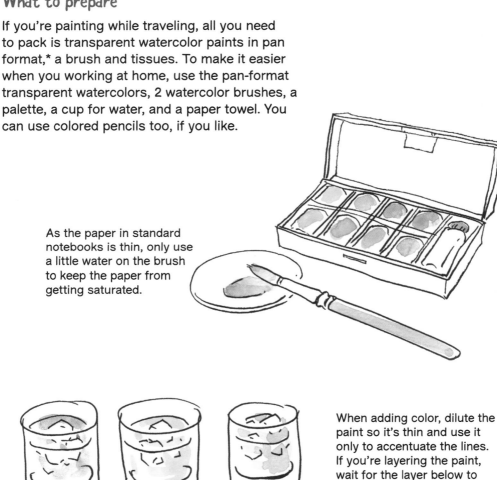

As the paper in standard notebooks is thin, only use a little water on the brush to keep the paper from getting saturated.

When adding color, dilute the paint so it's thin and use it only to accentuate the lines. If you're layering the paint, wait for the layer below to dry before applying the next one. The trick is to leave plenty of white regions.

* In this book, I use Winsor & Newton Professional and Schmincke Horadam watercolor paints.

1. Food item sketches are painted after you've eaten, so make a note of the dish names and ingredients. Here I started by painting the calzone. I observed light tones with darker colored edges on the food, so I painted it faint orange, while leaving areas of white.

Mineral water

My 2nd today!

Fresh salad with ingredients >

Chicken calzone

2. For the baked color of the calzone and chicken, use the same orange color and paint it in layers to create a darker shade. The chicken has a darker color than the crust, so I layered in additional paint for that. Wait for the paint to dry before applying the next layer. As you layer in contrasting bright and deep colors, it creates a beautiful look.

Mineral water

My 2nd today!

Fresh salad with ingredients >

Chicken calzone

3 For lettuce, add color to the leaf tips and leave the bottom white. Bell pepper has a bright color, so here I added yellow layers. I layered red for the tomato too, but left a part unpainted for the highlight. Tint the pickles and your meal is ready!

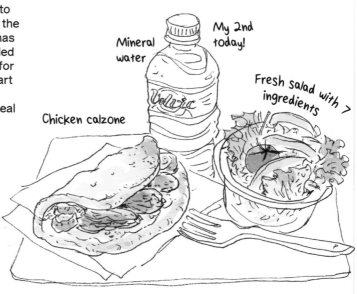

Mineral water

My 2nd today!

Fresh salad with > ingredients

Chicken calzone

4 Make sure to leave white parts on the plastic bottle. The illustration and logo used a lot more color, but as it had an overall impression of light blue, I colored it mostly like that. Paint the place mat a color you like, without adding any shadow, and your sketch is complete. It looks delicious, doesn't it?

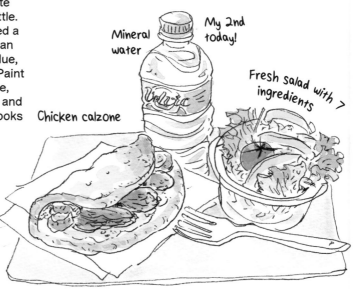

Mineral water

My 2nd today!

Fresh salad with > ingredients

Chicken calzone

Adding color to food

Sardine & tomato pasta

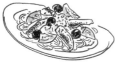 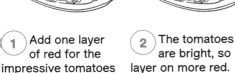

1 Add one layer of red for the impressive tomatoes and one of blue for the sardines. Apply a little yellow here and there too.

2 The tomatoes are bright, so layer on more red. Add yellow to the pasta.

3 Use orange for the grilled part of the sardines, layer purple for the olives, and make the colors stronger overall.

4 The light green of the scallions and tablecloth give a bright impression.

Stone-roasted bibimbap

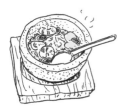 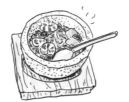 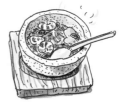

1 Use red, yellow and light green to separate the ingredients. Don't paint everything, just enough to note the colors.

2 Add more orange and pink. Add a light layer of orange to the wood.

3 Use brown and blue for the stone bowl. For the shadow, layer the color 2–3 times.

4 Add a brown shadow to the edge of the wood. Add touches of yellow. I added lines to indicate the steam rising from the bowl.

Udon noodles with deep-fried tofu

1 The delicious deep-fried tofu and soup stock is colored with 1 layer of orange.

2 Layer orange here and there to get the color of the tofu and stock right.

3 Add red to make it look even more tasty. In the Kantō region, the stock is a deeper color. Add the green for the scallions.

4 The color scheme is simple, so accent with orange and yellow.

At the Table

Eating is one of life's simple pleasures. It seems a waste to just fill up your tummy. Whether it's your everyday lunch or dinner on vacation, if you make a sketch, it becomes a wonderful memory.

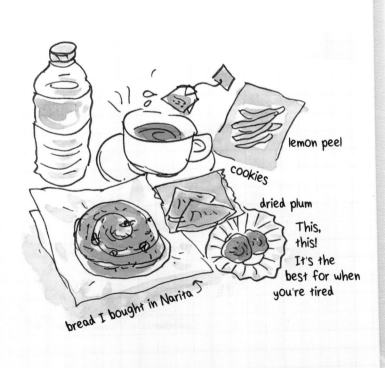

lemon peel

cookies

dried plum

This, this! It's the best for when you're tired

bread I bought in Narita ♪

Tasty Dishes

Served on a single plate, these are dishes that can satisfy your tummy and your eyes. It's fine to draw the food first and then draw the line of the plate last to surround it. Sketch a lovely picture and then enjoy adding to it with watercolors or colored pencils. Don't add any dark shadows.

Keema curry

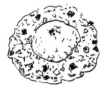

(1) Draw the outline of the fluffy scrambled egg on top.

(2) Make the lines gentle and fluffy. Like this.

(3) Add the outline of the curry, and then draw in the details of the ingredients.

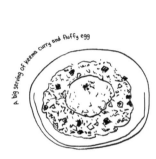

A big serving of keema curry and fluffy egg

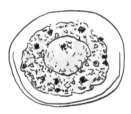

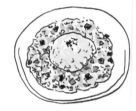

(4) Draw the plate last. Don't worry if it's a little distorted.

(5) The curry and the lighting had a strong yellow cast, so here I started with yellow.

(6) Make the egg a stronger yellow. Add orange and red accents to the curry.

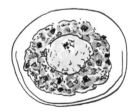

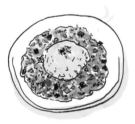

(7) If you felt it was spicier, add more red, plus some green bits for vegetables.

(8) I left off the pattern on the plate and added yellow as a shadow to give the impression of the restaurant and also to add "aroma lines."

Shrimp tempura with udon noodles

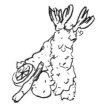

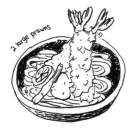

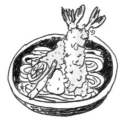

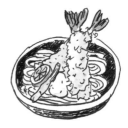

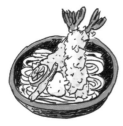

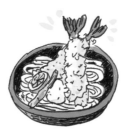

1. Start by drawing the shrimp tempura. Use fine movements to draw the coating.

2. I included a pickled ginger sprout.

3. Draw underlying items, like the second shrimp as shown here.

4. Draw the noodle bowl and add double lines inside for the udon noodles.

5. Color half of the fried coating yellow. Paint the shrimp tails orange.

6. Add pink and red to the tails, green for the lime slice, and a little yellow for the noodles.

7. Color the whole outside of the bowl red. Add brown on the inside.

8. Add more pink to the pickled ginger and yellow marks above the shrimp to finish.

2 large prawns

Creating a Meal Diary

If you make a sketch of your lunch every day in a small notebook, you will have a lunch diary. Record simple notes about the ingredients and the table setting too.

June 9, 2011 4:19 pm

Tokyo Midtown

B1 Atrium

Between interviews, to keep myself going, I went to Yonehachi on the same floor and bought a pack of 5 steamed savory rice pockets.

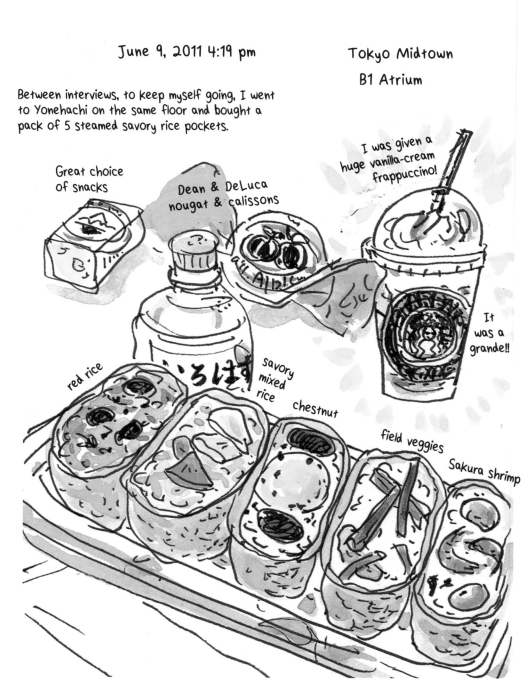

Great choice of snacks

Dean & DeLuca nougat & calissons

I was given a huge vanilla-cream frappuccino!

It was a grande!!

red rice

savory mixed rice

chestnut

field veggies

Sakura shrimp

June 17, 2011 4:30 pm

The April classes have finished.

Prep for tomorrow's tour.
First, I prepare my tummy...

@ Freshness Burger

Lots of lemon, but
it's submerged, so it
can't be seen

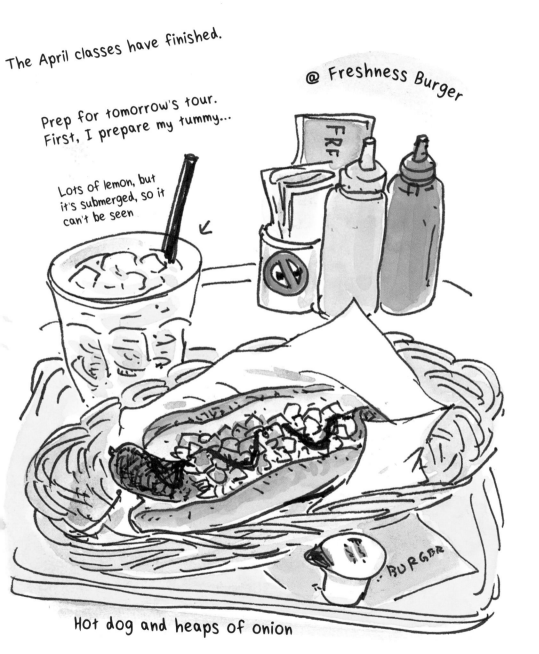

Hot dog and heaps of onion

May 31, 2011 1:00 pm @ home

Refreshing shirasu whitebait and
sakura shrimp rice bowl

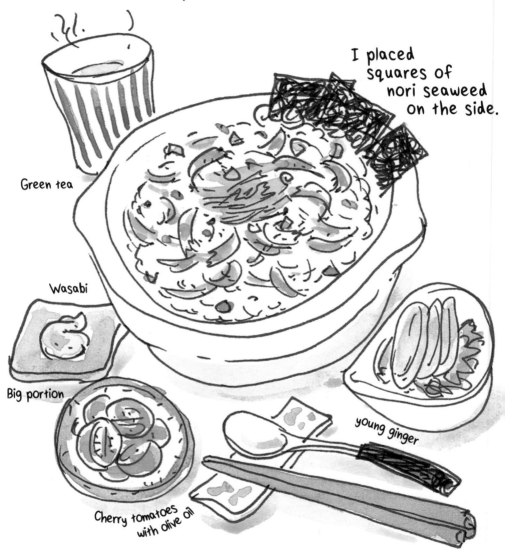

I placed
squares of
nori seaweed
on the side.

Green tea

Wasabi

Big portion

young ginger

Cherry tomatoes
with olive oil

June 1, 2011 2:00 pm @ home

Had a lot of chores...
So it was a very quick lunch.
But I ate well.

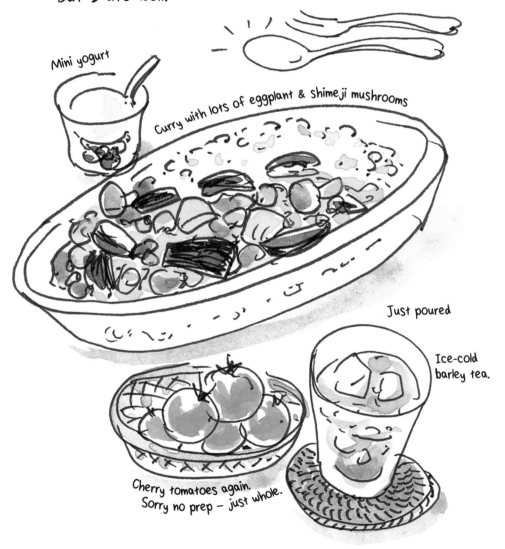

Mini yogurt

Curry with lots of eggplant & shimeji mushrooms

Just poured

Ice-cold
barley tea.

Cherry tomatoes again.
Sorry no prep — just whole.

My Meal Menu Journal

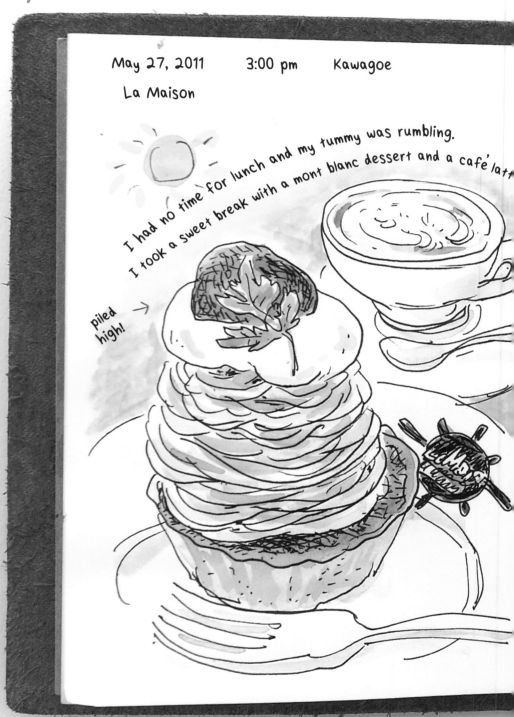

May 27, 2011 3:00 pm Kawagoe
La Maison

I had no time for lunch and my tummy was rumbling.
I took a sweet break with a mont blanc dessert and a café latt*

piled high!

May 28, 2011 12:45 pm @ Jitaku (home!)

So much tomato, mizuna & broccoli, you can't see the udon noodles.

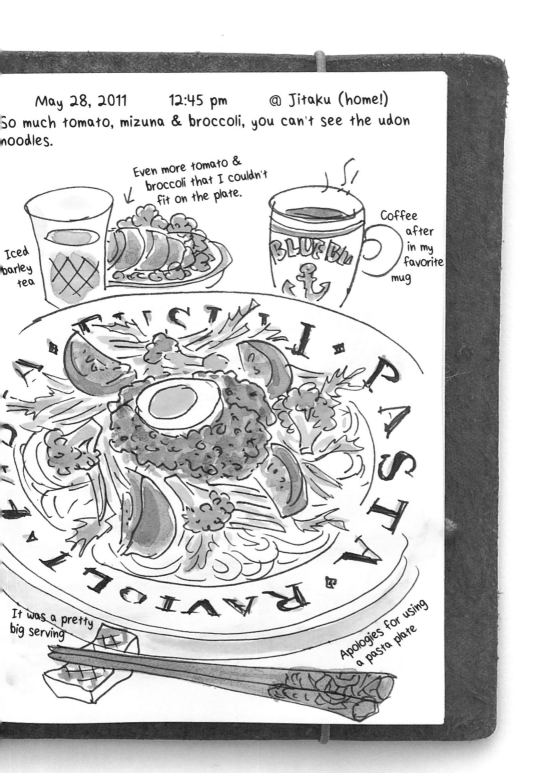

Even more tomato & broccoli that I couldn't fit on the plate.

Iced barley tea

BLUEBL

Coffee after in my favorite mug

It was a pretty big serving

Apologies for using a pasta plate

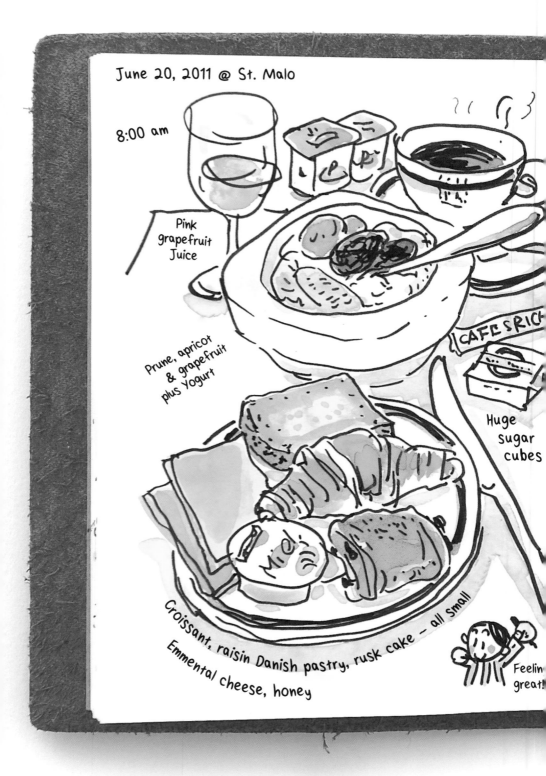

June 20, 2011 @ St. Malo

8:00 am

Pink grapefruit Juice

Prune, apricot & grapefruit plus Yogurt

CAFÉS RICH

Huge sugar cubes

Croissant, raisin Danish pastry, rusk cake — all small
Emmental cheese, honey

Feelin great!

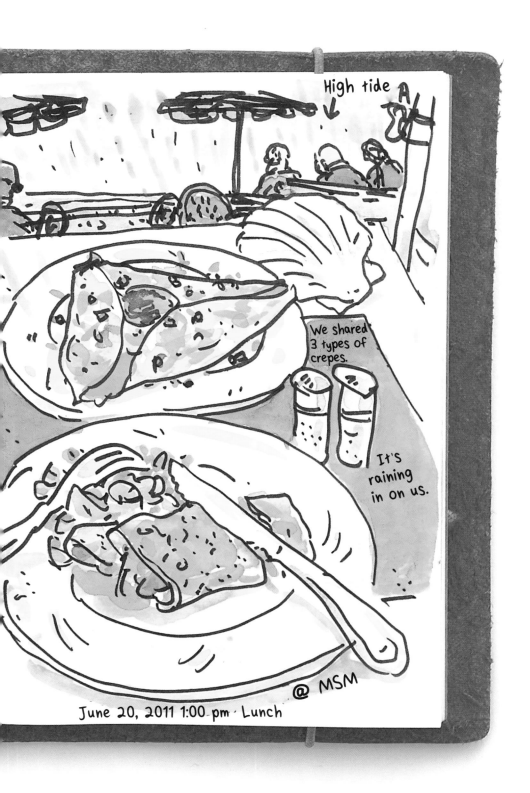

High tide

We shared 3 types of crepes.

It's raining in on us.

@ MSM

June 20, 2011 1:00 pm · Lunch

June 24, 2011 1:30 pm @ Paris !!!!

We see off the main tour group and
now it's only those who are staying
extra nights. We move to the
hotel in Paris and then
go for a walk.
My stomach is
growling!

They
warm it
for you

Chicken &
tomato panini

10 in

It's really big!!

But I finished it
eventually.

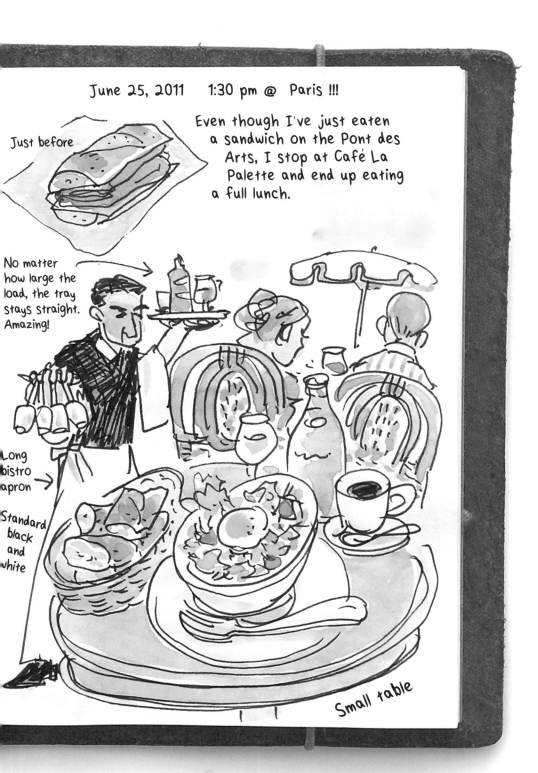

June 25, 2011 1:30 pm @ Paris !!!

Just before

Even though I've just eaten a sandwich on the Pont des Arts, I stop at Café La Palette and end up eating a full lunch.

No matter how large the load, the tray stays straight. Amazing!

Long bistro apron →

Standard black and white

Small table

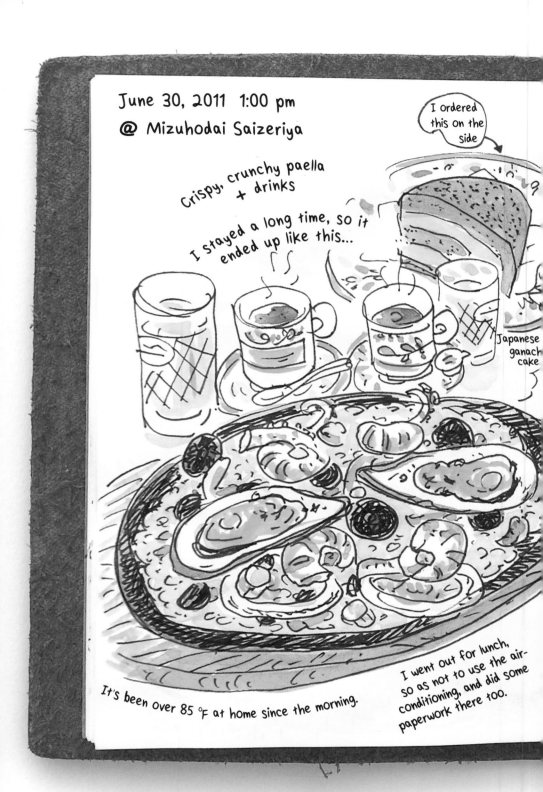

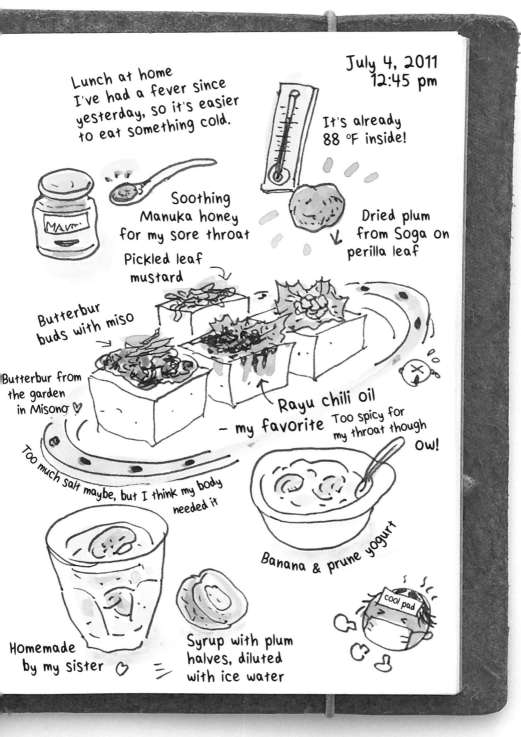

Lunch at home
I've had a fever since yesterday, so it's easier to eat something cold.

It's already 88 °F inside!

Soothing Manuka honey for my sore throat

Dried plum from Soga on perilla leaf

Pickled leaf mustard

Butterbur buds with miso

Butterbur from the garden in Misono ♡

Too much salt maybe, but I think my body needed it

Rayu chili oil – my favorite Too spicy for my throat though

Ow!

Banana & prune yogurt

cool pad

Homemade by my sister ♡

Syrup with plum halves, diluted with ice water

89

Meals with Rice

Can you remember what you ate for dinner last night? This is a sketch of a scene so ubiquitous that it can be overlooked. Whether it's laboriously prepared cuisine or an easy meal made in a hurry, I think everyday life is really delicious.

(1) For food like rice, soup and small bowl items that are served in deep dishes, draw the dish first. Draw a second line for the rim of the rice bowl, and then draw the rice.

(2) For the soup, draw the bowl first and then add a line for the surface of the soup. I redrew the line of the bowl, but left the original line as it was. For food on plates, draw the food first. Here I started with one slice of ginger.

(3) Draw in order of the ginger, the top fish fillet, and then the bottom fillet. Make sure the cross-section of the fish doesn't look flat. Draw the cavity where the insides have been removed. Doesn't it look realistic?

 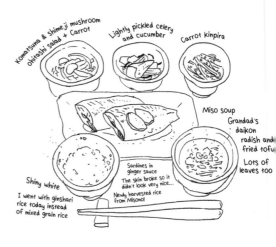

(4) Draw a plate around the food, and the main dish is done. Draw the small side dishes starting with the bowls. I added the chopsticks at this point.

(5) Draw the shapes of one whole shimeji mushroom and one piece of cucumber clearly. Draw the outline of the ingredients in the soup with broken lines. Then make notes of the dish names and the ingredients to finish.

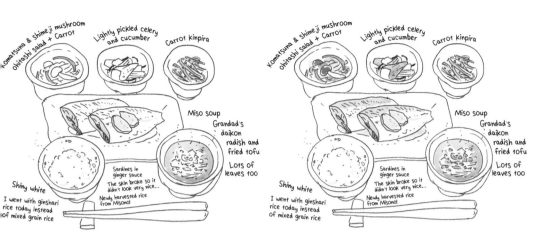

6) Add color. Fill the ginger in with yellow. I added a tiny amount to the rice too. Use orange to color the carrot, miso soup and sardines. Use less paint on the brush when working on detailed areas.

7) Add green and light green to the komatsuna, celery, cucumber and daikon radish leaves. It's starting to look delicious. But what about the color for the fish sauce? Let's try adding orange first.

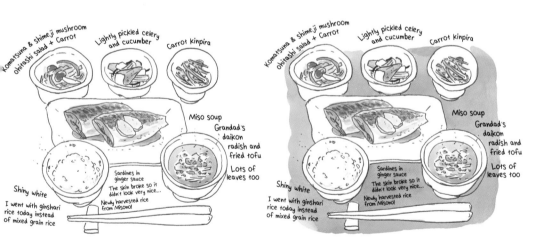

8) If you color the sardines blue, they will look raw. Here, I've added red and orange to give the impression of sauce, but I don't go too far with it. It doesn't have to look exactly as the food actually does. It's important to know when to stop.

9) The bowls were all different colors, so instead of painting them, I made the background red. It's fine to paint over the lines of the bowls without going to the trouble of erasing them. And now it's done!

91

Full-course Dinners

Food that comes in courses is the best way to enjoy making sketch notes. In photos, it's not possible to capture all the dishes in one shot, but with a sketch, you can draw little by little and record the whole meal on one piece of paper.

Etiquette

Ask at the restaurant if it's okay to sketch before you start. Be sure to eat at the same pace as the others sitting with you. Remember to tip and say "thank you" afterward.

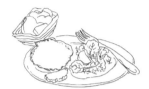

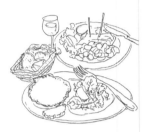

(1) Look at the menu and check how many dishes there are in the course. Then think about how large you want to draw each plate. The appetizer has now been served, so I started drawing from the shell here at the bottom of the sketch.

(2) Draw the salad, fork and plate, and then eat that food. The bread has now come, so let's add that.

(3) Just as I'd drawn the wine glass, the main dish arrived, so I sketched it above the appetizer. The glass and plate are overlapping, but we'll leave it like that.

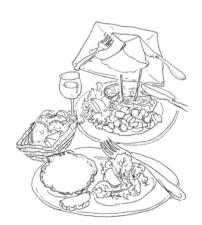

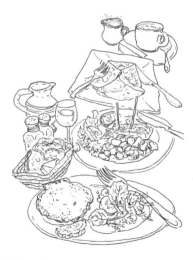

(4) Here, there was a little time before the dessert came, so I added scales to the sea bream.

(5) After drawing the square plate for the crepe, eat the dessert while it's still warm, and draw in the texture later. Once the coffee is served, that's everything. I also added in the pitcher of delicious cider.

6 At this point, the only item actually left on the table is the coffee cup. While slowly sipping coffee, I draw the people, add written notes, and then the sketch is complete.

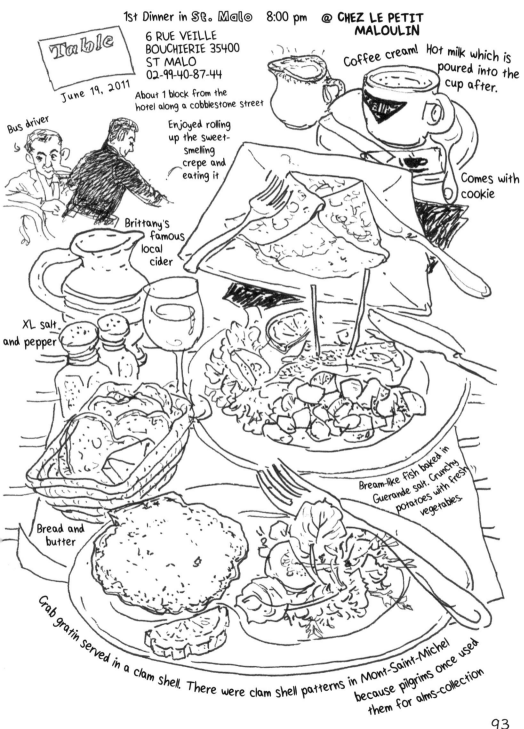

1st Dinner in St. Malo 8:00 pm @ CHEZ LE PETIT MALOULIN

Table

June 19, 2011

6 RUE VEILLE BOUCHIERIE 35400 ST MALO 02-99-40-87-44

About 1 block from the hotel along a cobblestone street

Coffee cream! Hot milk which is poured into the cup after.

Comes with cookie

Bus driver

Enjoyed rolling up the sweet-smelling crepe and eating it

Brittany's famous local cider

XL salt and pepper

Bream-like fish baked in Gueraude salt. Crunchy potatoes with fresh vegetables.

Bread and butter

Crab gratin served in a clam shell. There were clam shell patterns in Mont-Saint-Michel because pilgrims once used them for alms-collection

7. Now, let's add color to the delicious food I've enjoyed. You can't use paint in a restaurant, so wait until you get home before adding color. You'll forget tiny details, but that makes it just right. Look at the notes you made and use the colors that you recall when you read the names of the dishes and the ingredients. With parts you forget, just use a color you like.

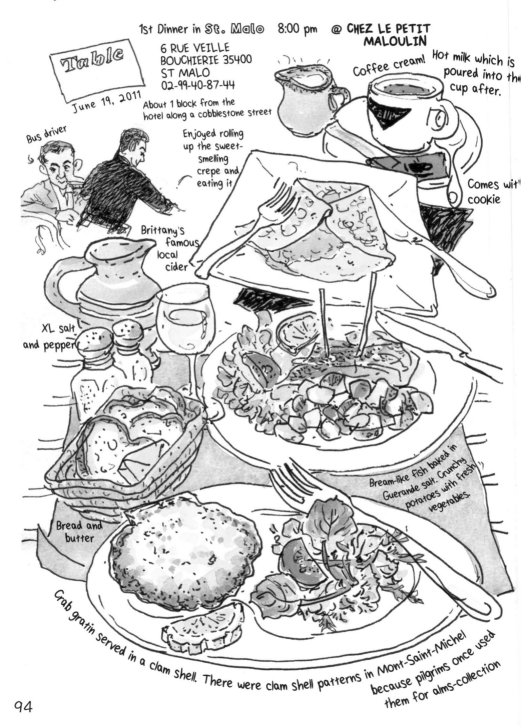

1st Dinner in St. Malo 8:00 pm @ CHEZ LE PETIT MALOULIN

Table

June 19, 2011

6 RUE VEILLE BOUCHIERIE 35400 ST MALO 02-99-40-87-44

About 1 block from the hotel along a cobblestone street

Coffee cream! Hot milk which is poured into the cup after.

Comes with cookie

Bus driver

Enjoyed rolling up the sweet-smelling crepe and eating it

Brittany's famous local cider

XL salt and pepper

Bream-like fish baked in Guerande salt. Crunchy potatoes with fresh vegetables.

Bread and butter

Grab gratin served in a clam shell. There were clam shell patterns in Mont-Saint-Michel because pilgrims once used them for alms-collection

94

In-flight Meals

Making a sketch of the in-flight meal is one of the fun parts of traveling. Highlights include compact containers, a cup with the airline logo on it, cutlery and a small wine bottle. Draw the meal quickly and then enjoy eating it while it's still warm.

Etiquette

Take care not to disturb the people around you. If there's strong turbulence or a need to tidy up quickly, check to make sure that it's okay to sketch. If you follow good manners while sketching, it can lead to wonderful conversations.

June 18, 2011 11:00 pm (JPN) in
the air over Münster

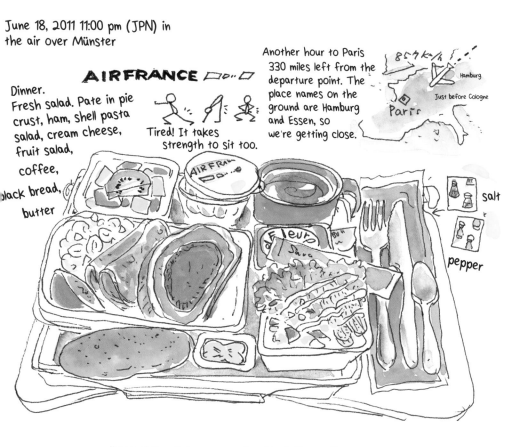

Another hour to Paris 330 miles left from the departure point. The place names on the ground are Hamburg and Essen, so we're getting close.

857 km/h
Hamburg
Just before Cologne
Paris

AIRFRANCE

Dinner.
Fresh salad. Pate in pie crust, ham, shell pasta salad, cream cheese, fruit salad,
coffee,
black bread,
butter

Tired! It takes strength to sit too.

AIR FRA

Fleur
Sauv

salt

pepper

Even if the dishes seem jumbled, they will come together at the end when you draw the lines of the tray, so don't worry.

It's also fine if the plane shakes, creating wobbly lines.
Don't rush. You can correct things when you add color.

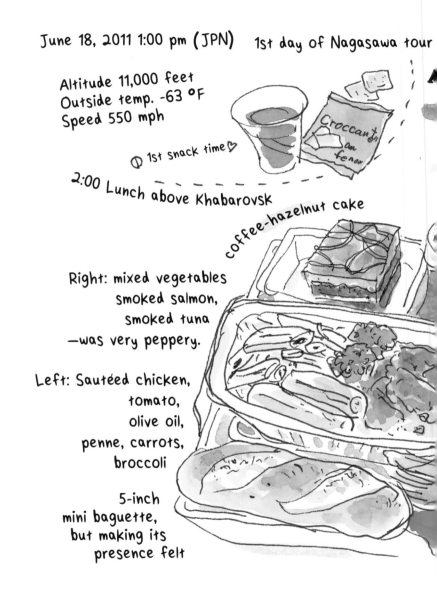

June 18, 2011 1:00 pm (JPN) 1st day of Nagasawa tour

Altitude 11,000 feet
Outside temp. -63 °F
Speed 550 mph

① 1st snack time ♡

2:00 Lunch above Khabarovsk

coffee-hazelnut cake

Right: mixed vegetables
smoked salmon,
smoked tuna
—was very peppery.

Left: Sautéed chicken,
tomato,
olive oil,
penne, carrots,
broccoli

5-inch
mini baguette,
but making its
presence felt

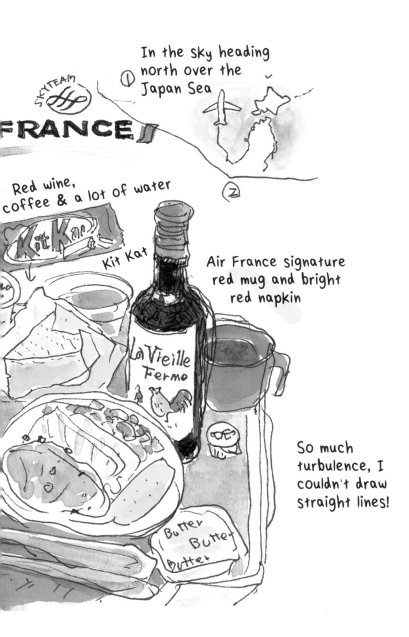

In the sky heading north over the Japan Sea

Red wine, coffee & a lot of water

Kit Kat

Air France signature red mug and bright red napkin

So much turbulence, I couldn't draw straight lines!

La Vieille Fermo

Butter Butter Butter

Once you've sketched, eat your meal while it's warm. Make menu notes to help you remember colors more easily.

December 22, 2009 3:20 pm

Air France. The drink service started. Felt relaxed, so I had red wine. Except I drew the back of the bottle. The front looked like this.

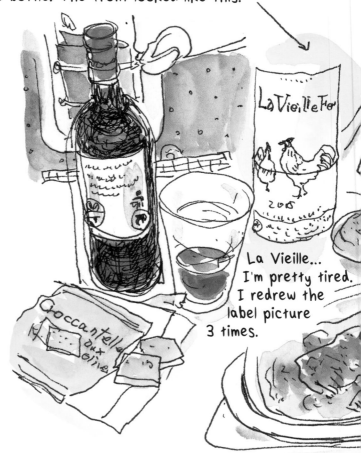

La Vieille...
I'm pretty tired.
I redrew the
label picture
3 times.

Beef ragout and mustard sauce, cucumber and tomato salad,
salmon, Camembert cheese, butter, mandarin
orange, chocolate tartlet,
coffee, water, Potato,
spinach, carrot, celery

If you don't fill the page with the in-flight meals,
add some other sketches and notes too.

The time in France is 11:50 pm, December 22, 2009
Outside the window is frozen land and
bright sky. In Japan, the time is 7:50 am
on the 23rd.

The last in-flight service. 10.5-hour
flight. A little more time to feel like
I'm on vacation in France.

Häagen-Dazs

The midnight snack
was a Haagen-Dazs
ice cream bar ♥

Compote
de Fruits
POMMES·COING

Delicious

↗ Breakfast was bread, butter, jam,
plain yogurt, apple compote (a bit

A winter wonder-land

After eating, we were on approach to Japan

Morioka Tokyo

Osaka

Hakodate

Japan is flipped around

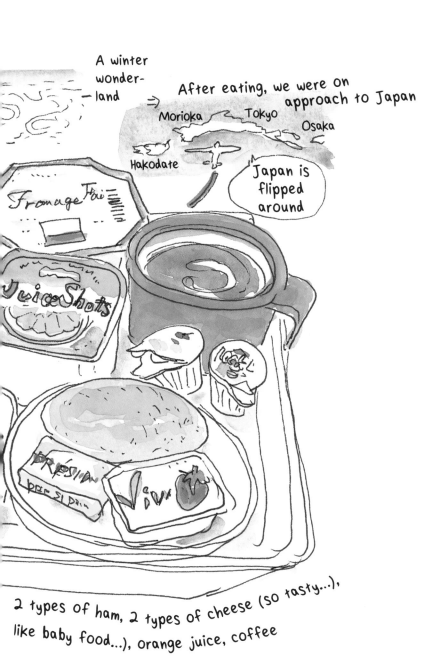

Fromage Fai

Juice Shots

PRESDIAN per si prin

Viva

2 types of ham, 2 types of cheese (so tasty...), like baby food...), orange juice, coffee

I felt the picture was missing something with just the meal, so I included a can of beer and the printed menu.

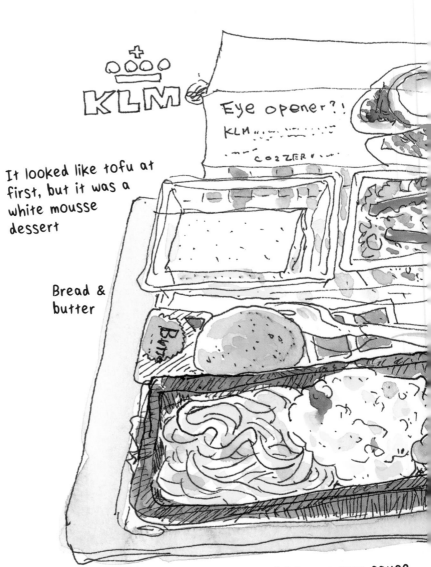

It looked like tofu at first, but it was a white mousse dessert

Bread & butter

Pasta, carrots & spinach, chicken cream sauce

June 19, 2010 Arles Tour 1st day

 KLM Regular flight

Got to Japan time 3:30 and meal time. The 250 ml can of
Heineken was so cute, so I went for that. I was tired and
at an altitude of 31,500 feet, so it really hit me.

Flaked crab & corn salad
 with green
 beans &
 lettuce.

← I drank half and
 felt dizzy

The plastic knife
and fork were really
sturdily made.

On the Road

I get excited when I hear the word "travel."
Where shall I go? What should I eat?
What's well-known there? But first of all,
what should I wear? And what sketches
can I do? Even before setting out, the fun
of travel has started.

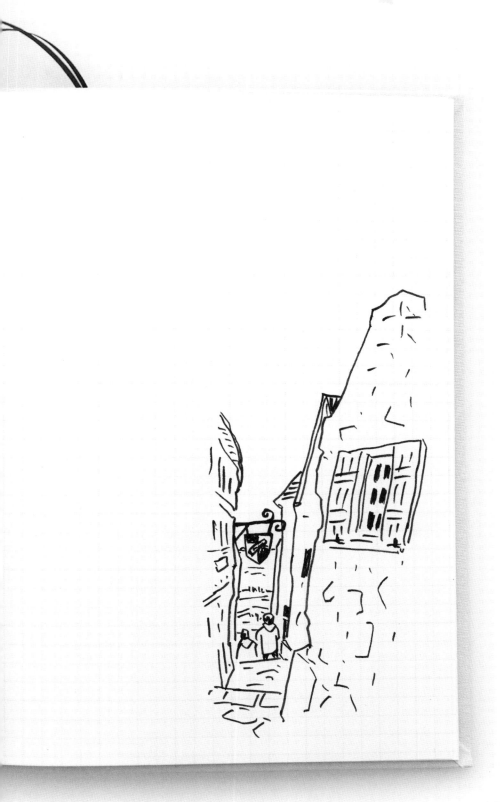

My Travel Diaries

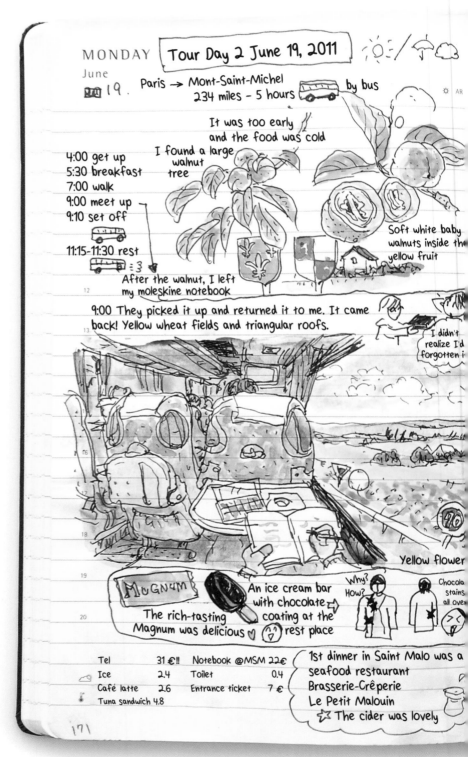

MONDAY | Tour Day 2 June 19, 2011

June
19.

Paris → Mont-Saint-Michel
234 miles – 5 hours by bus

It was too early
and the food was cold

I found a large
walnut
tree

4:00 get up
5:30 breakfast
7:00 walk
9:00 meet up
9:10 set off

11:15-11:30 rest
≡ 3

Soft white baby
walnuts inside the
yellow fruit

After the walnut, I left
my moleskine notebook

9:00 They picked it up and returned it to me. It came
back! Yellow wheat fields and triangular roofs.

I didn't
realize I'd
forgotten it

12

13

16

18

19

Yellow flower

MuGNuM
An ice cream bar
with chocolate
coating at the
rest place

The rich-tasting
Magnum was delicious ♡

Why?
How?

Chocola
stains
all over

20

Tel	31 €!!	Notebook @MSM	22€	
Ice	2.4	Toilet	0.4	
Café latte	2.6	Entrance ticket	7 €	
Tuna sandwich	4.8			

1st dinner in Saint Malo was a
seafood restaurant
Brasserie-Crêperie
Le Petit Malouin
☆ The cider was lovely

171

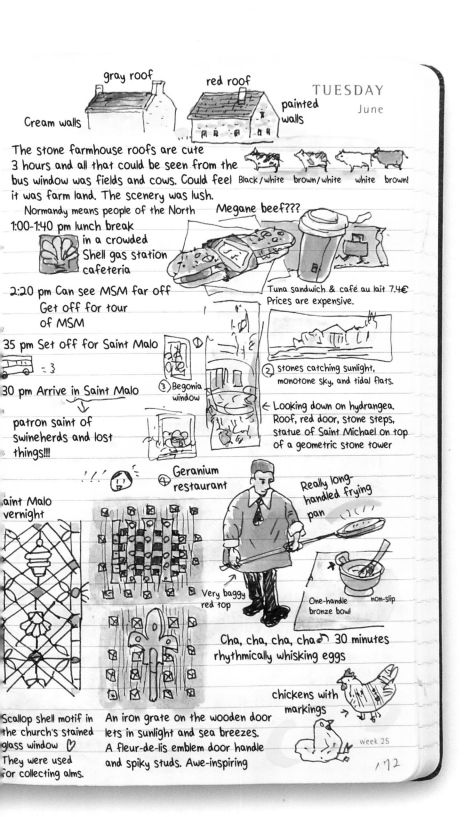

gray roof

red roof

Cream walls

painted walls

The stone farmhouse roofs are cute
3 hours and all that could be seen from the
bus window was fields and cows. Could feel
it was farm land. The scenery was lush.

Black/white brown/white white brown!

Normandy means people of the North

Megane beef???

1:00-1:40 pm lunch break
in a crowded
Shell gas station
cafeteria

Tuna sandwich & café au lait 7.4€
Prices are expensive.

2:20 pm Can see MSM far off
Get off for tour
of MSM

35 pm Set off for Saint Malo

= 3

② stones catching sunlight,
monotone sky, and tidal flats.

30 pm Arrive in Saint Malo

③ Begonia
window

← Looking down on hydrangea.
Roof, red door, stone steps,
statue of Saint Michael on top
of a geometric stone tower

patron saint of
swineherds and lost
things!!!

④ Geranium
restaurant

Really long-
handled frying
pan

Saint Malo
overnight

Very baggy
red top

One-handle
bronze bowl

non-slip

Cha, cha, cha, cha♪ 30 minutes
rhythmically whisking eggs

chickens with
markings →

Scallop shell motif in
the church's stained
glass window ♡
They were used
for collecting alms.

An iron grate on the wooden door
lets in sunlight and sea breezes.
A fleur-de-lis emblem door handle
and spiky studs. Awe-inspiring

week 25

172

107

Itineraries

When I was a child, I loved school trip itineraries. If you make your own travel itinerary, you're sure to have a special trip. Look at brochures, books and travel programs to choose what you want to do—delicious food to eat, things to buy and places to see—then sketch them.

You don't have to draw one page for each day—make it for all the days you will travel or stay on your trip. If you add a map, it makes it easier to imagine where everything was, and drawing your mode of transportation helps you better recall your travels.

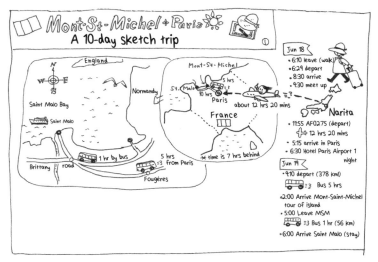

For small towns not included in guidebooks, it's good to look at a map on the internet and sketch that. When you only have a little information, leave some space so you can fill it in later.

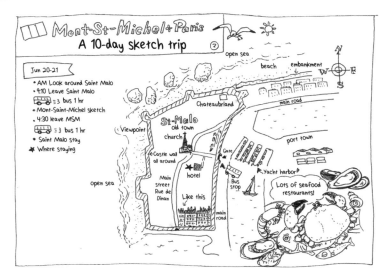

For famous tourist destinations, don't copy straight from the guide book—pick what interests you and focus on that information.

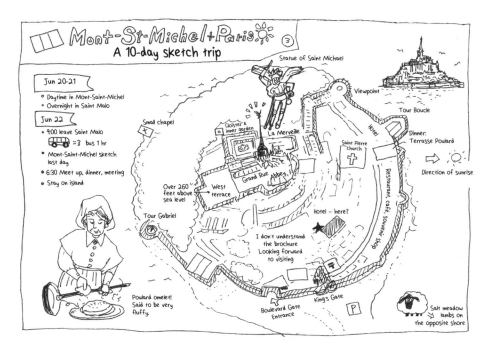

It's useful to note where the hotel is and which transportation and station names you will use. Here, I added the food I could buy. This would be fun to color in too.

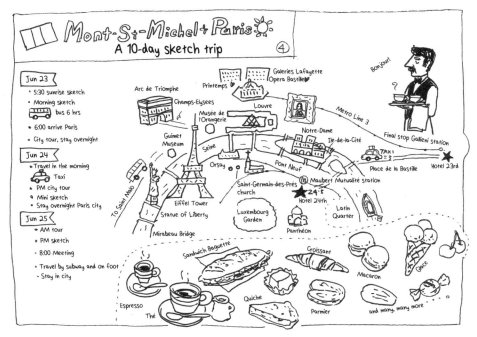

Clothes to Pack

You want to travel light on your trip. But you also want to enjoy being stylish. Try using sketch notes to organize your clothes. It makes it easier to coordinate outfits too.

Holiday packing list

You don't have to draw in fine detail—as long as you can see the characteristics, it will remind you what you need to pack. Draw the items at the same scale so it's easier to see the differences in length and width.

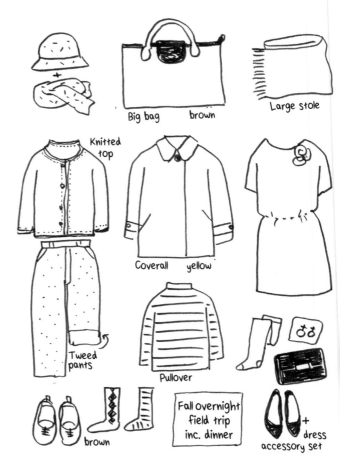

Big bag brown

Large stole

Knitted top

Coverall yellow

Tweed pants

Pullover

Fall overnight field trip inc. dinner

brown

dress accessory set

Various ways to draw shoes

If you want to make a note of the sole shape, draw the shoe from the side.

When you want to show the toe and decorative features, draw it from overhead.

And if you want to include the heel, look at the shoe from a 45-degree angle, so you can see the whole shape.

An ensemble of clothes

A tip for distinguishing sketches of articles of clothing that are similar is to pay attention to the details in the areas that are different. For shirts, show the length, the collar, front opening and cuffs. For pants, draw the length, width, waist and pockets.

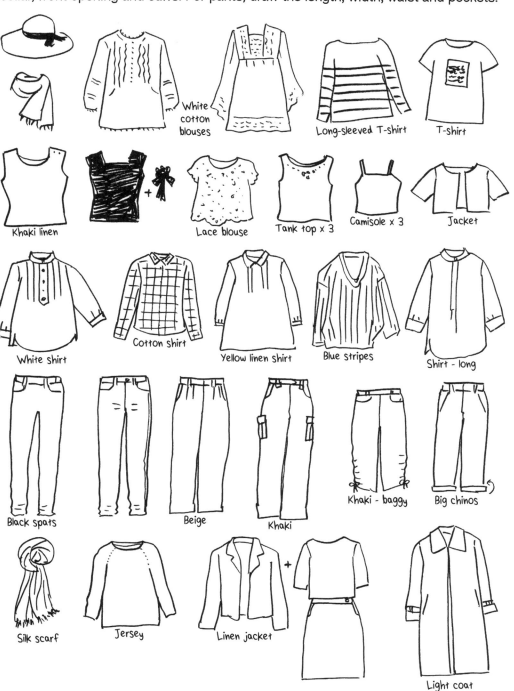

White cotton blouses

Long-sleeved T-shirt

T-shirt

Khaki linen

Lace blouse

Tank top x 3

Camisole x 3

Jacket

White shirt

Cotton shirt

Yellow linen shirt

Blue stripes

Shirt - long

Black spats

Beige

Khaki

Khaki - baggy

Big chinos

Silk scarf

Jersey

Linen jacket

Light coat

Floor Plans

Here, I'll show you how to draw a plan of the hotel room where you are staying. To start, it's easier to use graph paper or other ruled paper. As you draw the walls, add where the furniture is too.

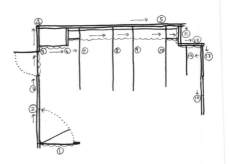

1 I started here by measuring the door (at the bottom) with my hands and then opened the door to use it as a marker for the length of the wall. I measured the bathroom door with my hands too. That helped me gauge the depth of the room.

2 I then drew the back wall, and measured the closet, side table and bed in that order with my hands, which gave me the dimensions to the right wall. Then I measured the protruding column and that helped me gauge the width of the room.

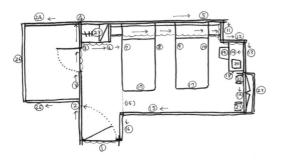

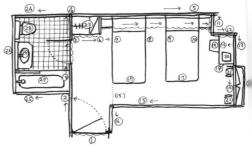

3 The length of the wall in the foreground ran to the edge of the bed closest to the door, so with that, the whole shape of the room was set. The length of the beds can either be measured or the distance estimated from the wall and then you can draw them. It's fine to look at the furniture to get an idea of the balance and then draw those. When you want to draw something accurately, be sure to measure it.

4 Add the bathroom to the sketch the same way, by drawing the wall first and then adding details. For a tile floor, it's good to draw it using the tile squares as a measure.

Try a 3D floor plan sketch

Play around with making the floor plan slightly three-dimensional. Use a pencil when drawing.

1 Draw the floor plan in pencil.

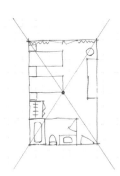

2 Make diagonal lines from the center of the plan, drawing them outward.

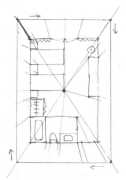

3 Draw lines parallel to their adjacent floor edges all around, forming the 4 walls.

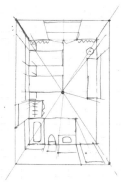

4 Draw a line from the center out to each part of the floor plan. The door and window are now visible.

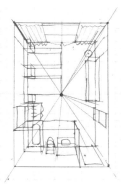

5 Estimate the height of the furniture by the height of the wall. Go around the room and draw the height of the chest of drawers and bed.

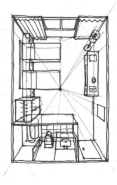

6 Draw over with pen. The furniture that appeared to be just transparent boxes is now clearly visible.

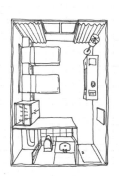

7 Erase the pencil lines, and you're done.

CANPANILE PARIS EST PORTE DE BAGNOLET

28 Av du General de Gaulle BA, CEDEXF

I could finally see the Eiffel Tower after a 6-hour bus ride!! I spotted Grand Paris, Orsay, Louvre, Notre-Dame and all the sightseeing spots across the map. Tonight's hotel is above the exit of Gallieni station, the last stop on Metro Line 3.

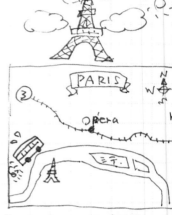

Wherever you go on the Metro, it's 1.7€, so it's easy to understan To Opera in the center, it's 12-13 stations. Well, it's only 1 night.

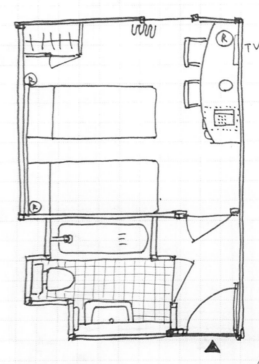

← Very minimal room. But it has a kettle and fridge. The bathtub is the smallest yet.

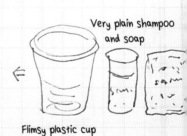

Very plain shampoo and soap

Flimsy plastic cup

The drier worked well

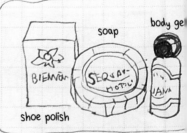

body gel

soap

BIENVAn

SEQ∪A⁻ moʊ

JAvA

shoe polish

MODERNEST GERMAIN (2 NIGHTS)

Rue des Ecoles, Paris, France

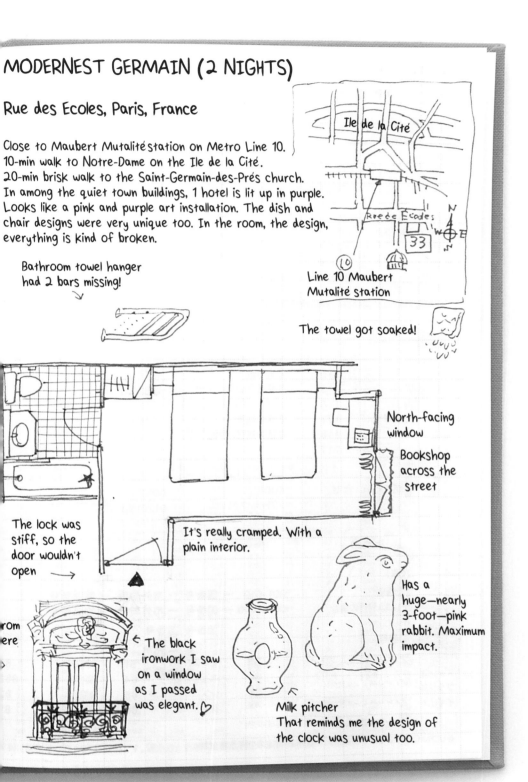

Close to Maubert Mutalité station on Metro Line 10.
10-min walk to Notre-Dame on the Ile de la Cité.
20-min brisk walk to the Saint-Germain-des-Prés church.
In among the quiet town buildings, 1 hotel is lit up in purple.
Looks like a pink and purple art installation. The dish and
chair designs were very unique too. In the room, the design,
everything is kind of broken.

Ile de la Cité

Rue de Ecoles

33

N
W E
S

Bathroom towel hanger
had 2 bars missing!

Line 10 Maubert
Mutalité station

The towel got soaked!

North-facing
window

Bookshop
across the
street

The lock was
stiff, so the
door wouldn't
open →

It's really cramped. With a
plain interior.

Has a
huge—nearly
3-foot—pink
rabbit. Maximum
impact.

rom
ere

← The black
ironwork I saw
on a window
as I passed
was elegant.

Milk pitcher
That reminds me the design of
the clock was unusual too.

HOTEL DU LOUVRE (3 NIGHTS)

Rue de Marins, St Malo, France

A stonework town surrounded an immensely high embankment
and castle walls. All the stone houses are 4 floors and the
roofs are all the same height.

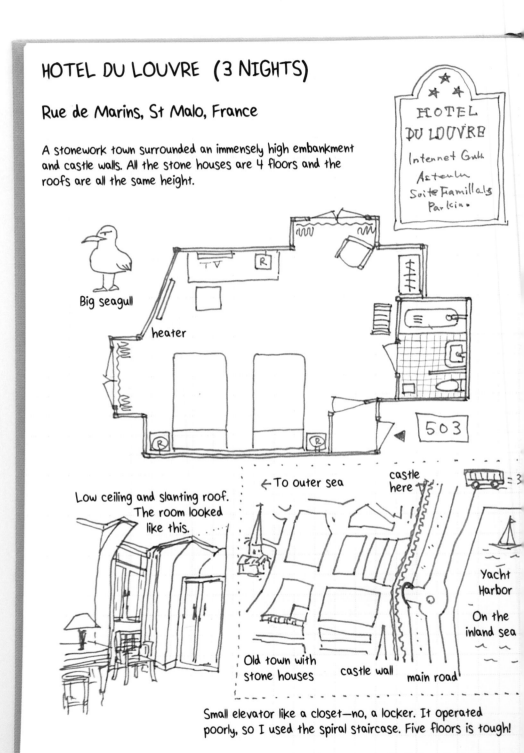

HOTEL
DU LOUVRE
Internet Gulk
Asteuln
Soite Famillals
Par kin•

Big seagull

heater

TV

R

503

Low ceiling and slanting roof.
The room looked
like this.

←To outer sea

castle
here

Yacht
Harbor

On the
inland sea

Old town with
stone houses

castle wall

main road

Small elevator like a closet—no, a locker. It operated
poorly, so I used the spiral staircase. Five floors is tough!

TERRASSES POULARD (1 NIGHT)

Le Mont Saint Michel, France

A small island of about a 1,640-foot diameter with routes everywhere, connected by steps and steep paths like a maze. The porter carried my bags up the stone steps from the hotel reception to the room in the annex. Two suitcases nearly 45 lbs each. He was sweating a lot. Very much appreciated.

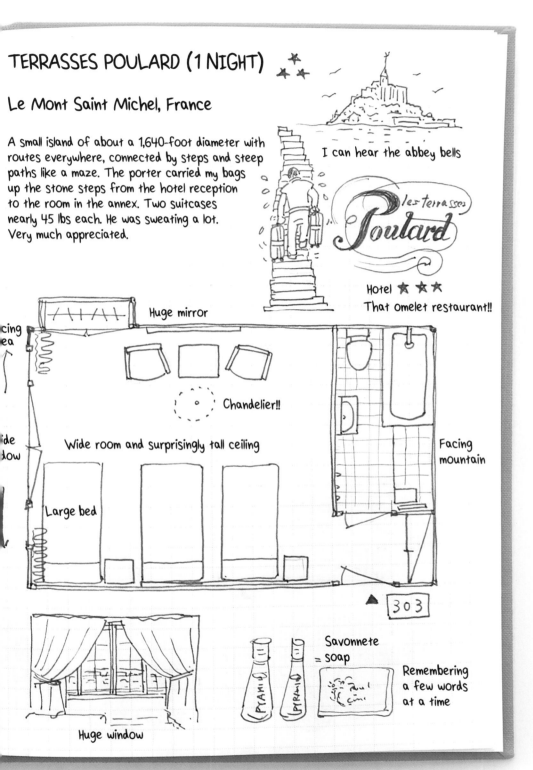

I can hear the abbey bells

les terrasses Poulard

Hotel ★ ★ ★
That omelet restaurant!!

Huge mirror

Chandelier!!

Wide room and surprisingly tall ceiling

Facing mountain

Large bed

cing ea

ide ow

303

Huge window

Savonnete = soap

Remembering a few words at a time

PYRAMID PYRAMID

Destination Sketches

Quick, small sketches made while traveling. I get excited just thinking about it. You might feel a little self-conscious at first, but once you start, the local people will come to look and chat with you. When you come across a beautiful scene, feel free to grab your pen.

Drawing with a bold-tip pen

A bold-tip pen is good for sketching rough impressions. I wanted to capture the atmosphere of the building down the alley, so I left out the detailed decorations.

The streetlight, drawn quickly with a bold-tip pen, has more sense of strength and speed than it would if I was using a fine-tip pen.

Drawing with a fine-tip pen

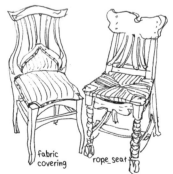

fabric covering rope seat

Musée d'Orsay June 25, 2011
The Art Nouveau furniture collection was great.

I wanted to note the thickness of the wooden components and the details of the cord and frames, so I used a fine-tip pen. This type of pen is handy for drawing intricate items.

The Musée d'Orsay restaurant. The chandeliers and ornate windows are indescribably beautiful.

June 25, 2011
Second floor restaurant at Musée d'Orsay
Chandelier, ornate window frame, wide view of
roofs out of the window. Wonderful. A beauty
I can't capture in a picture.

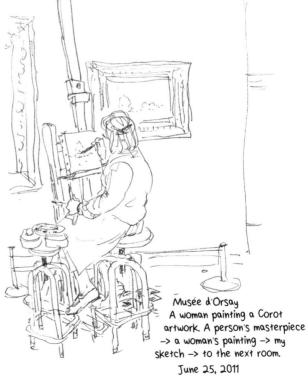

I spotted a woman making a copy of a painting in the Musée d'Orsay. It was an original by Corot and in a place that didn't even have any intervening protective glass. How great!

Musée d'Orsay
A woman painting a Corot
artwork. A person's masterpiece
-> a woman's painting -> my
sketch -> to the next room.
June 25, 2011

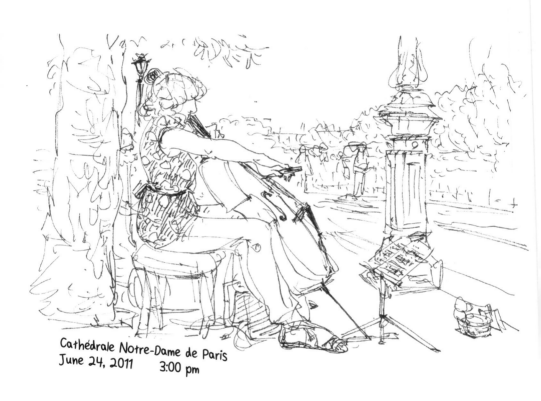

Cathédrale Notre-Dame de Paris
June 24, 2011 3:00 pm

A woman playing a cello in the park by Notre-Dame. The musical selection is full of notes.

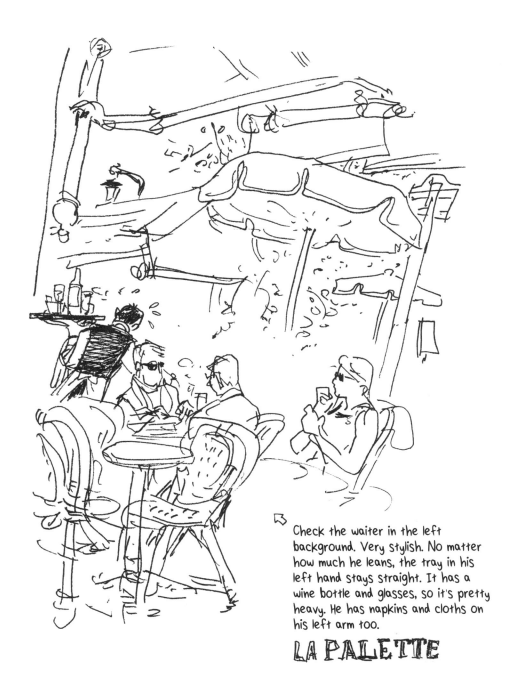

Check the waiter in the left background. Very stylish. No matter how much he leans, the tray in his left hand stays straight. It has a wine bottle and glasses, so it's pretty heavy. He has napkins and cloths on his left arm too.

LA PALETTE

The waiter's movements are elegant. The tray stays horizontal, no matter how much he leans. He catches my eye and raises an eyebrow, as if to ask, "Did you draw me?"

Sketching People

Every day at the train station and in the town, a lot of people pass by. When someone appears on your radar, sketch them in your notebook. Cool clothes, a quirky walk, or a beautiful outfit—note the elements you like and you may gain some insights.

People I Met Along the Way

It makes me feel quite happy when I see a stylish person. Most of the time I will carry on by and forget the moment, but here is where I took out my notebook and sketched. Someday it will be part of a collection of stylish looks.

Drawing a stylish person

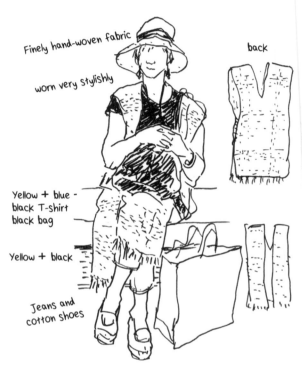

Finely hand-woven fabric

worn very stylishly

back

I couldn't stop myself from saying to the woman sitting next to me on the JR Yamanote Line, "That's beautiful fabric." She told me it was handwoven, so I asked if I could draw it. The seat across was free, so I sat there and sketched.

Yellow + blue - black T-shirt black bag

Yellow + black

Jeans and cotton shoes

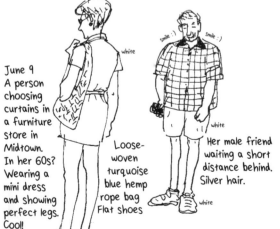

white

June 9
A person choosing curtains in a furniture store in Midtown. In her 60s? Wearing a mini dress and showing perfect legs. Cool!

Loose-woven turquoise blue hemp rope bag Flat shoes

smile :) smile :)

white

Her male friend waiting a short distance behind. Silver hair.

white

A woman, probably in her sixties, who I spotted in Tokyo. She was wearing a bright-white, short, one-piece dress. It was fascinating how neat her legs appeared. The image of her companion, standing a little way off, smiling and waiting, was lovely too.

Drawing children

A child's physical appearance is different, depending on their age. Infants have plump wrists and ankles, while toddlers have quite slender legs. They don't stand still often, so sketch them while they are concentrating on something.

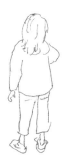

If you try to draw kids too cutely, they become like a manga character. To begin with, just draw as you see them.

Her delicate ankles, visible below her pant cuffs, were cute, so I drew them finely. Her hands are small too.

Kids' heads are larger and legs smaller than adults. There is a slight unsteadiness to the way they stand too.

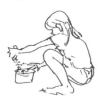

Absorbed with playing in the sand. Since she's making exaggerated movements, I emphasized her arms and legs.

Compared to adults, kids' necks are thinner and their shoulders are narrower, so if you can convey that, they will look like a child even from behind.

Sketching notable parts

If you are trying to draw a person, but they are looking more like a doll, take a look at the hands and feet you've drawn. Are they too small? Draw them a bit larger, so you can see what the hands are doing or what kind of shoes they're wearing.

If you look at your hands and observe the way your finger joints bend, it will make drawing hands easier.

It is a good idea to draw fingernails to make you aware of the difference in direction between the thumb and other fingers.

Try drawing the characteristics of the shoes.

It's not possible to see the joints and fingernails here, so focus on capturing the overall shape.

For sandals, draw the toes too. The toenails are a key point.

Draw above the shoes. Practice by sketching boots and legwarmers. If you can draw as far as the knees, consider it a success.

Sketching on a Train

On the train, there are people of all ages and occupations, making it perfect for people watching. It's best to start practicing by discreetly sketching a person who's sleeping or has their back to you. This trains you to sketch very quickly.

Etiquette

You're using a pen, so avoid times when it's crowded and you're likely to be jostled or unintentionally jab a fellow commuter. Take care not to stare, so that you don't make the person you're drawing and the people around you feel uncomfortable.

Standing commuters

Search for creases in their clothes on the seat of their pants and behind their knees, and draw them in.

When people are facing sideways, look carefully at the leg farthest from you. It won't be the same length as the leg closest to you—it will always appear a little shorter.

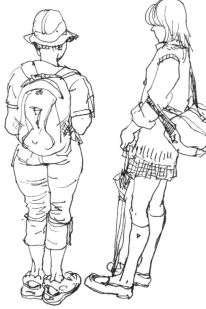

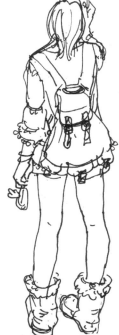

When you look at shoes from behind, you can't always see the toes. Visualize their orientation while you draw them.

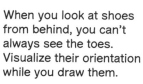

When someone is leaning, their head and legs are out of alignment. Draw what they are leaning on too.

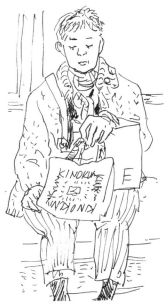

Here, the knees can be seen from under the bag, so I continued on to the legs.

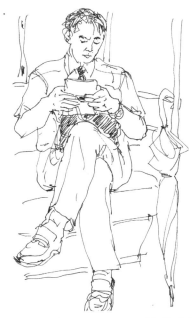

Try sketching a person with their legs crossed from the front. Draw their upper and lower legs, so that they join with the outer lines of their body.

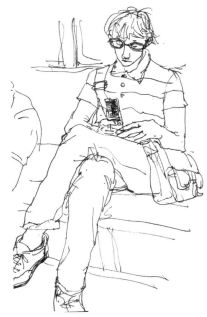

When someone has their legs crossed, look carefully at where their lower legs are, so you can connect them with their body.

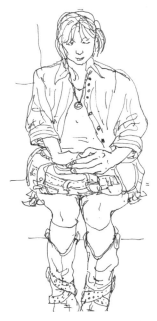

It's difficult to draw the bulge of the kneecap, so just suggest it with a light line.

Kimiko Sekimoto is an award-winning artist who graduated from Joshibi University of Art and Design. She works as a freelance illustrator and teaches pen-sketching courses at Waseda University in Japan. She has shown her artworks in dozens of exhibitions since 2005.

Published by Tuttle Publishing, an imprint of Periplus Editions (HK) Ltd.

www.tuttlepublishing.com

ISBN 978-4-8053-1684-9

TECHO SKETCH
Copyright © 2011 Kimiko Sekimoto
Original Japanese edition published in 2011
by SB Creative Corp.
English translation rights arranged with
SB Creative Corp., Tokyo through
Japan UNI Agency, Inc., Tokyo

Staff (Original Japanese edition)
Design Terumi Hara, Ayumi Hoshino
 (Mill Design Studio)
Photography Seiji Mizuno (front endpapers; pages
 4–7; 10–13; 20–25; 34–35; 44–53; 62–
 63; 74–75; 82–89; 104–107; 114–117
 and 122–123; back endpapers)
Editor Mari Yagi

English translation © 2022 Periplus Editions (HK) Ltd
Translated from Japanese by Wendy Uchimura

Printed in Malaysia 2202TO
26 25 24 23 22 10 9 8 7 6 5 4 3 2 1

Distributed by:

North America, Latin America & Europe
Tuttle Publishing
364 Innovation Drive
North Clarendon
VT 05759-9436 U.S.A.
Tel: (802) 773-8930
Fax: (802) 773-6993
info@tuttlepublishing.com
www.tuttlepublishing.com

Japan
Tuttle Publishing
Yaekari Building 3rd Floor
5-4-12 Osaki Shinagawa-ku
Tokyo 141 0032
Tel: (81) 3 5437-0171
Fax: (81) 3 5437-0755
sales@tuttle.co.jp
www.tuttle.co.jp

Asia Pacific
Berkeley Books Pte. Ltd.
3 Kallang Sector, #04-01
Singapore 349278
Tel: (65) 6741-2178
Fax: (65) 6741-2179
inquiries@periplus.com.sg
www.tuttlepublishing.com

TUTTLE PUBLISHING® is a registered trademark of Tuttle Publishing, a division of Periplus Editions (HK) Ltd.

"Books to Span the East and West"

Tuttle Publishing was founded in 1832 in the small New England town of Rutland, Vermont [USA]. Our core values remain as strong today as they were then—to publish best-in-class books which bring people together one page at a time. In 1948, we established a publishing office in Japan—and Tuttle is now a leader in publishing English-language books about the arts, languages and cultures of Asia. The world has become a much smaller place today and Asia's economic and cultural influence has grown. Yet the need for meaningful dialogue and information about this diverse region has never been greater. Over the past seven decades, Tuttle has published thousands of books on subjects ranging from martial arts and paper crafts to language learning and literature—and our talented authors, illustrators, designers and photographers have won many prestigious awards. We welcome you to explore the wealth of information available on Asia at **www.tuttlepublishing.com**.

June 24, 2011 1:30 @ Paris !!!!

We see off the main tour group and
now it's only those who are staying
extra nights. We move to the
hotel in Paris and then go
for a walk.
My stomach is
growling!

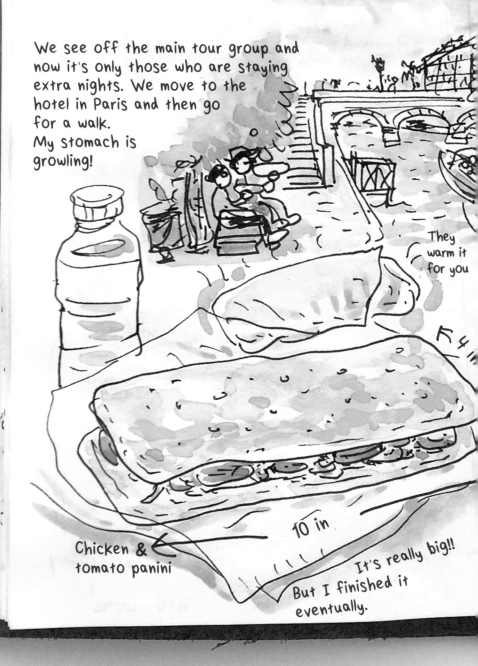

They
warm it
for you

10 in

Chicken &
tomato panini

It's really big!!
But I finished it
eventually.